Happy forty-ninth!

INDIANA FROM THE AIR

INDIANA
FROM

INDIANA UNIVERSITY PRESS / INDIANA DEPARTMENT OF NATURAL RESOURCES

Bloomington and Indianapolis

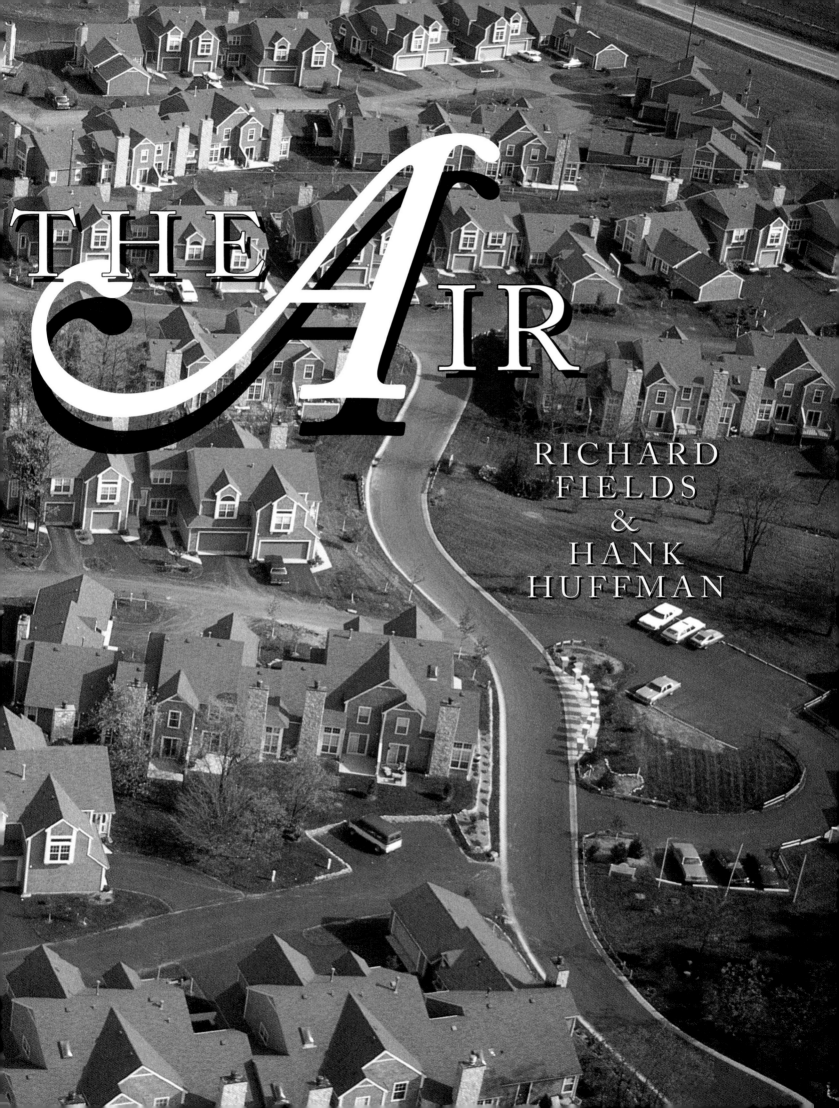

THE AIR

RICHARD
FIELDS
&
HANK
HUFFMAN

The paper used in this publication meets the minimum requirements of American
National Standard for Information Sciences—Permanence of Paper for Printed
Library Materials, ANSI Z39.48-1984.

Printed in Singapore

Library of Congress Cataloging-in-Publication Data

Fields, Richard.
Indiana from the air / Richard Fields and Hank Huffman.
p. cm.
ISBN 0-253-33224-9 (alk. paper)
1. Indiana—Aerial photographs. I. Huffman, Hank. II. Title.
F527.F54 1996
917.72'0022'2—dc20 96-3942

1 2 3 4 5 01 00 99 98 97 96

THIS BOOK IS DEDICATED TO OUR PARENTS

Donald and Elizabeth Fields & Millard and Lorene Huffman

AND ESPECIALLY TO THE MEMORY OF

Samuel Parker Fields

JULY 11–NOVEMBER 5, 1986.

Introduction

by Richard Fields

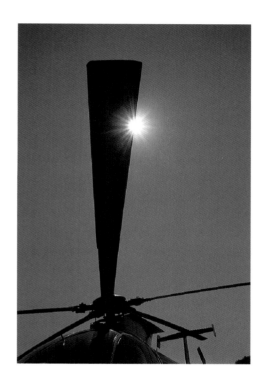

Sitting alone in the back seat, right side, of the Department of Natural Resources helicopter, a green and white McDonnell Douglas 500E, I lean forward and twist right to poke my lens out of a vertical slot in the Plexiglas window. Lenses, maps, filters, and film boxes cover the seat beside me. About 700 feet below, a filmy-looking, lime-green layer of tiny aquatic plants—duckweed—covers the eastern surface of a small kettle lake formed by glaciers over 10,000 years ago. A dirt path cuts straight through an adjacent cornfield and stops at the water's edge. A weathered johnboat is overturned beside the path. From this altitude I can see that the water along the western side of the lake is transparent. A marl shelf, composed of the calcified remains of plants and animals many thousands of years old, is visible through the water hugging the inner lakeshore.

Hank breaks in over the headset. His voice is surprisingly clear above the roar of the turboprop engine that sits about two feet over my head.

"OK. This is our next target. We'll want to circle this and then start looking for a block of woods that way."

He points northeast. The pilot acknowledges with an "OK."

We bank clockwise around the lake and an updraft pitches the aircraft abruptly. I brace the camera, compose intuitively, and adjust the aperture to compensate for changing light conditions. The sun is behind me as I expose the last of four frames. Each exposure counts. There is no way to return to this exact same spot or to duplicate these conditions.

For the past ten years, my work as Chief Photographer for the Indiana Department of Natural Resources and *Outdoor Indiana* magazine has allowed me the opportunity to experience much of the state intimately at ground level. A few previous flights to make oblique aerial photographs for specific agency-related projects had produced a small collection of "nuts and bolts" photography portraying isolated areas around the state. However, a call from John Gallman at Indiana University Press in March 1993, proposing a book of aerial photography representing the entire state, presented a rare and exciting opportunity—not only to expand greatly upon existing work, but also to create an original, new interpretive view of the Hoosier state from above. The concept of revisiting many "old haunts" from the air (and the prospect of seeing many other places for the first time) was intriguing. Hank and I immediately began to draft plans for the upcoming book.

I was especially pleased to be able to collaborate with my good friend Hank Huffman on this project. Hank and I have been best friends since our second-grade year at Maple Crest Elementary School in Kokomo. Through Cub Scouts and Boy Scouts, high school and college years, and now, as DNR professionals, we have shared some remarkable experiences in the Indiana outdoors. Hank's expertise in interpreting maps, his knowledge of Indiana history, folklore, biology, and extensive preflight preparations were crucial in enabling us to make the very best of our limited time in the air. The vast majority of the photographs presented here were created during five separate flights spanning a two-and-one-half year period, beginning in the spring of 1993 and concluding in the fall of 1995.

Indiana is a geologically complex state blessed with wonderful biological diversity. From Lake Michigan in the north to the Ohio River in the south, Indiana covers nearly 23 million acres spread out through 92 counties. Over 5.5 million Hoosiers call Indiana their home. Although considerable efforts were taken to give an accurate, balanced view of the state, it is simply not possible to cover everything in one hundred photographs. In the end, some photographs were selected for their merits in illustrating a particular location, while others were chosen for their aesthetic value. Collectively, the photographs presented here are probably more akin to a visual interpretation of Indiana than a documentary record, although we would like to think that we have the bases fairly well covered on both accounts.

The sweeping oblique views that one experiences flying in small aircraft at low altitudes are perspectives that no map can provide vicariously and that most commercial aircraft fly too high and too fast to allow. Moving low and

※

slow over the land, especially during the early morning and late afternoon hours when the sun casts long shadows, allows subtle variations in surface topography to become visible, differences that are not normally observed at ground level. Most of the photographs presented here were made at altitudes of between 500 and 1500 feet and recorded on 35mm slide film (Fujichrome Velvia, ISO 50). A Nikon F4 camera body was selected for its extra mass and resistance to the constant vibrations experienced aloft. In addition, the F4's spot-metering capability made it possible to select specific areas within a scene for critical exposure readings—scenes that otherwise varied widely in terms of overall luminance and contrast. The use of supplementary filters was kept to a minimum because they cut down on the light available to make exposures at 1/500 second. However, graduated neutral density filters, which allow the photographer to make choices about darkening selected portions of the image without sacrificing shutter speed, were occasionally hand-held in front of the lens in order to reduce the overall brightness of the sky above the horizon. Lenses in the 35mm to 135mm range generally gave the best results. Wider lenses tended to include portions of the main rotor as it spun at a constant rate overhead. Longer lenses seemed to magnify the constant vibration of the aircraft and also made it difficult to track subjects passing below through the four-inch by nine-inch vertical slot that my window provided.

Looking down upon Indiana from 1200 feet up (more or less), I was often struck by the contrast in imagery that memory held of certain places I have known since childhood and the new impressions that began to take shape as these areas were viewed from above. Dynamic new patterns emerged from the higher perspective, revealing ways in which the landscape has changed over thousands of years of exposure to wind, water, and vegetation: ancient seabeds of limestone entrenched by meandering streams; vast expanses of fertile soil deposited by glaciers and brought to light by pioneer settlers who cleared native forests to establish farms in the "wilderness"; wind-blown sand dunes in the north; undulating, unglaciated hills to the south; and the broad river valleys carved by the Wabash and Ohio Rivers.

Perhaps the most striking aspect of the aerial perspective is the extent to which man's presence can be seen. From fields and highways, cities and towns, to remote cabins and trailers scattered in forests and woodlots, human influences on the Hoosier landscape are omnipresent at 1200 feet. While some of these impacts are graceful and seem to complement the surround-ings—winding backcountry roads, terraced fields, or tilling patterns that follow natural contours—others are not. The helicopter has provided a unique

way of rising above the treetops in order to get a better look at our roots. Without getting too philosophical, it seems that the timing of this project has provided us with an opportunity to take a brief visual inventory of the state as we approach the new millennium.

Collaboration between Indiana state government, as represented by the Indiana Department of Natural Resources, and Indiana University, as represented by Indiana University Press, has made this publication possible. Both partners are glad that they were able to get together to do something meaningful and exciting for the state. We hope that it may provide a model for similar ventures involving governmental bodies, universities, and private industry in years to come.

Hank and I feel very fortunate to have had the opportunity to participate in this survey of the Hoosier state and to share our perspective with others. We are also pleased that the DNR's proceeds from the sale of this book will be directed to the Indiana Heritage Trust Fund for the acquisition of additional unique and threatened lands to expand Indiana's public land base. Not only our generation but future generations of Hoosiers deserve to share in the rich diversity and heritage of this state.

We would like to thank our pilots, Dennis Rumley and Ronald Whetstone, for their extraordinary dedication, patience, and skill in making all of our flights productive and successful. Likewise, we wish to thank the many divisions of the Indiana Department of Natural Resources that contributed valuable air time and other assistance to this project. Special thanks go to the Division of Public Information and Education and the Division of Nature Preserves for initiating the agency's involvement in this project and for continued support in bringing the project to completion. Thanks also to Bill Oliver Jr. and Travis Vencel for donating time in their hot air balloons; to my photographic mentors—Will Counts, Larry West, and Bill Thomas; to Dan Henkel, who kept the project on track; and especially to our families—my wife, Myrna, sons Riley and Ethan, and Hank's wife, Ellen—for putting up with us.

❋

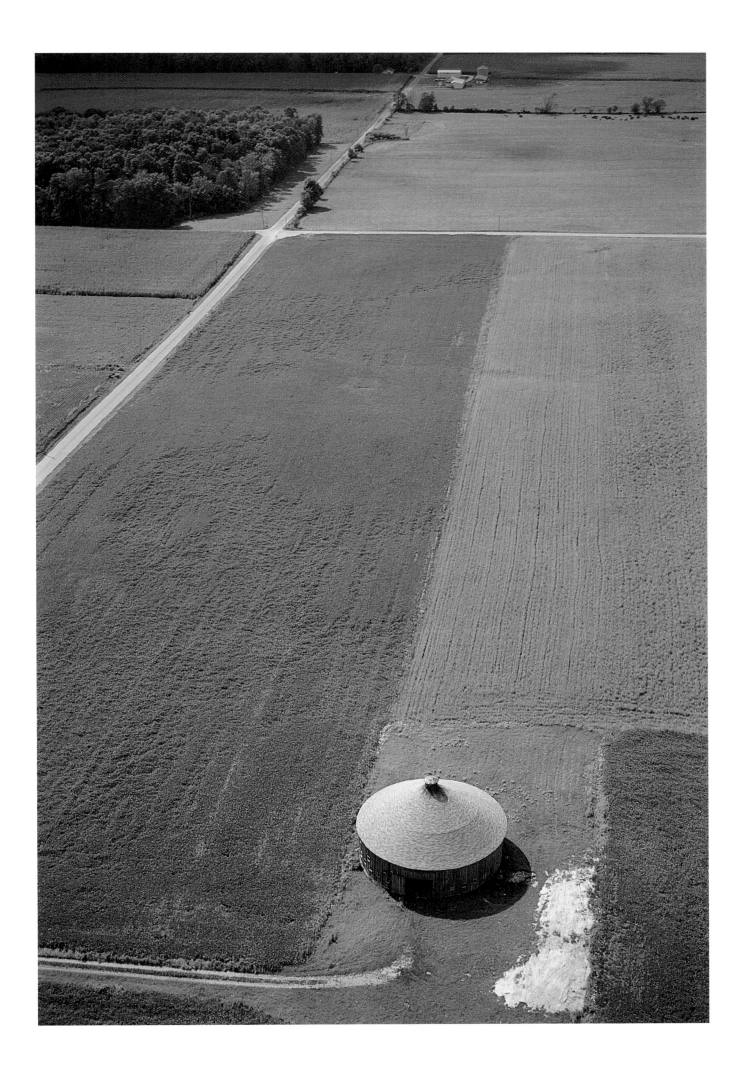

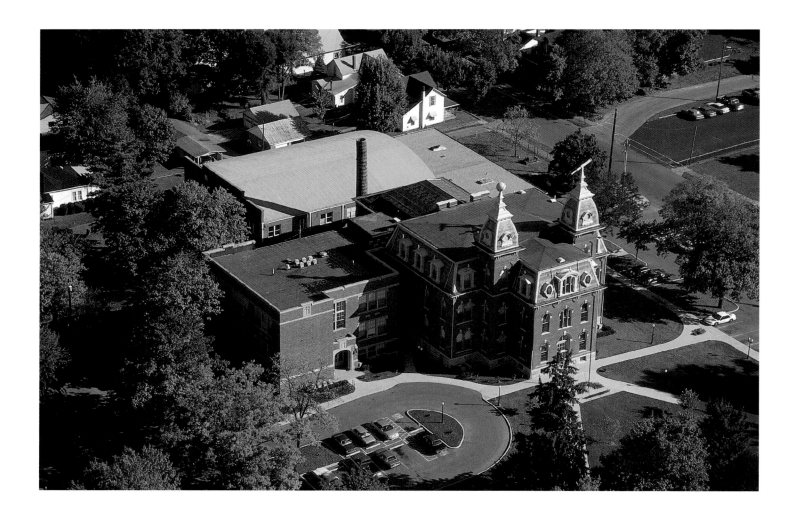

*A telescope and a globe top the twin towers
of Knightstown Academy in Knightstown,
Henry County. Now a historic landmark,
it was built in 1876 and for years was one
of the finest private schools in the state.*

☀

*The Pyramids office complex, northwest
side of Indianapolis, Marion County.*

☀

FOLLOWING SPREAD: *Patterns of the fall
harvest. A cornfield in Johnson County.*

PRECEDING PAGE: *Shortly after the turn of
the century the construction of round
barns for improved efficiency became
popular. Today Fulton County boasts
more of these picturesque structures than
any other county.*

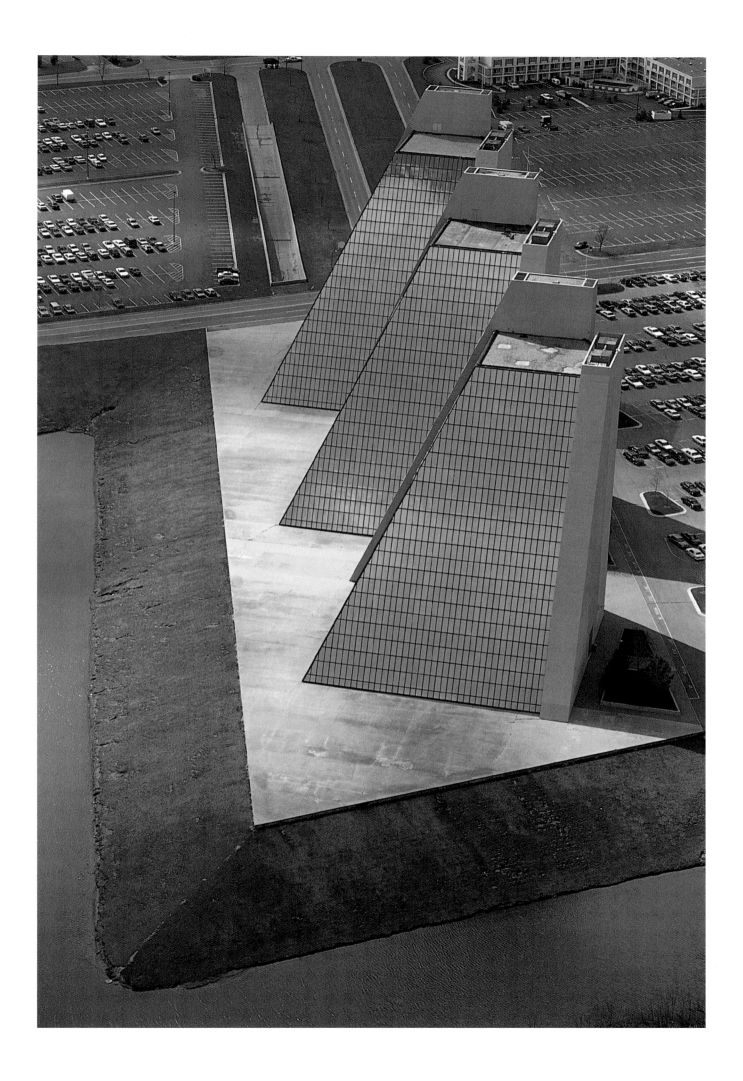

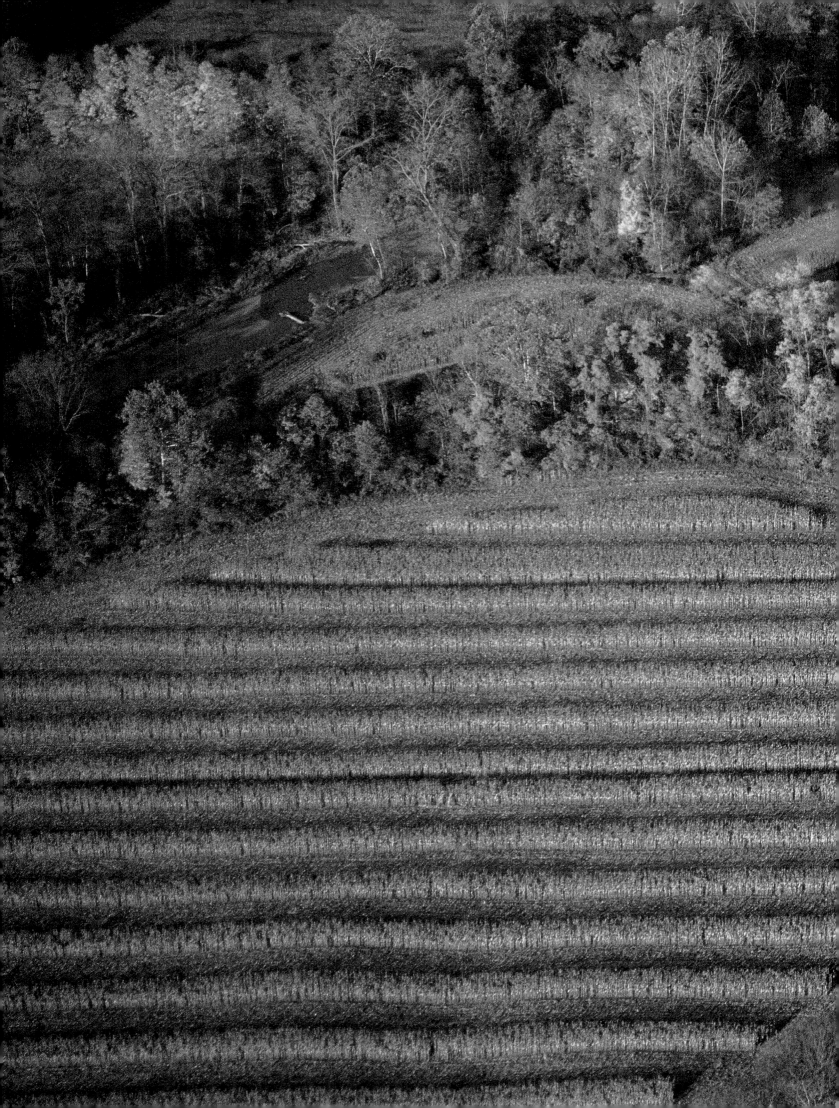

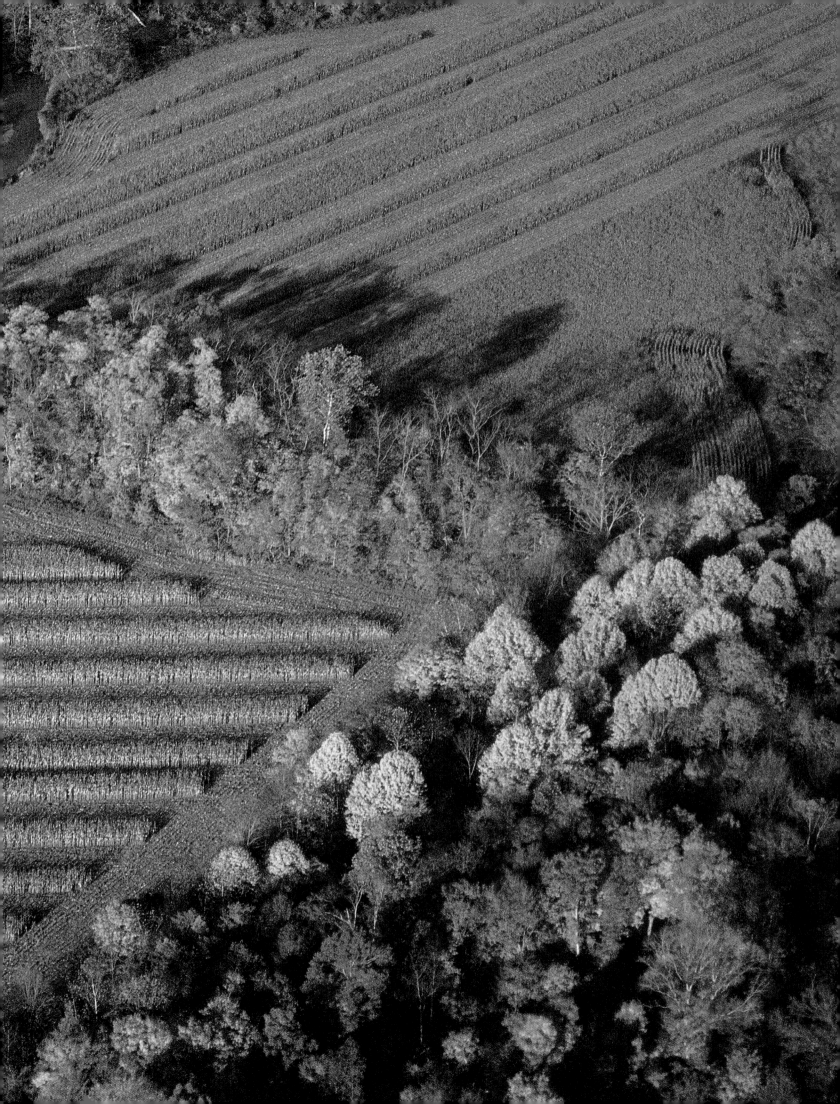

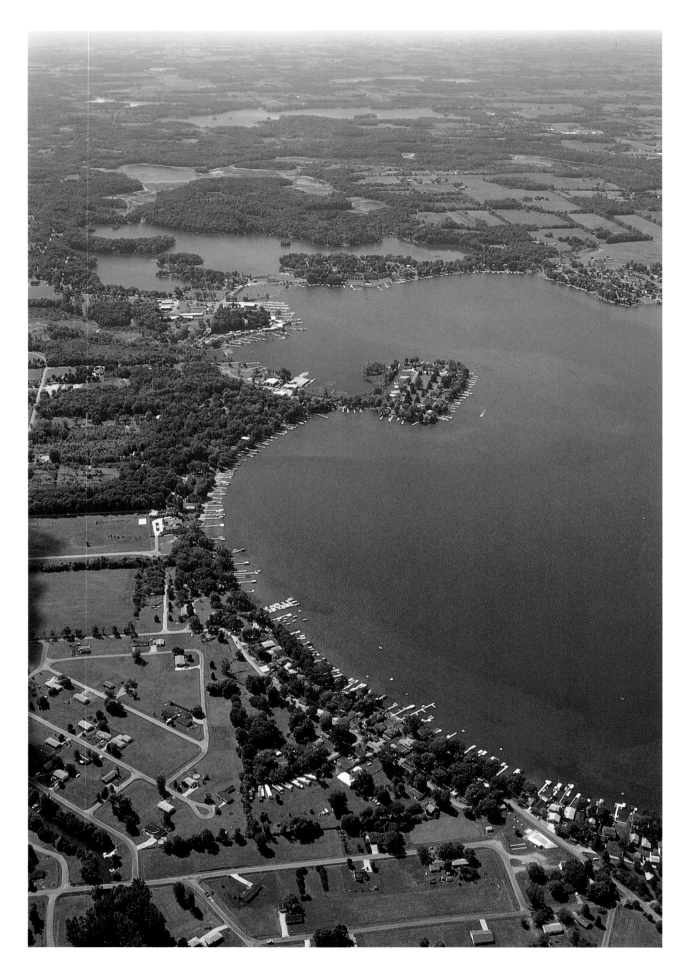

*Summer cottages and piers ring the shoreline of Lake Wawasee,
Kosciusko County, the largest natural lake in Indiana.*

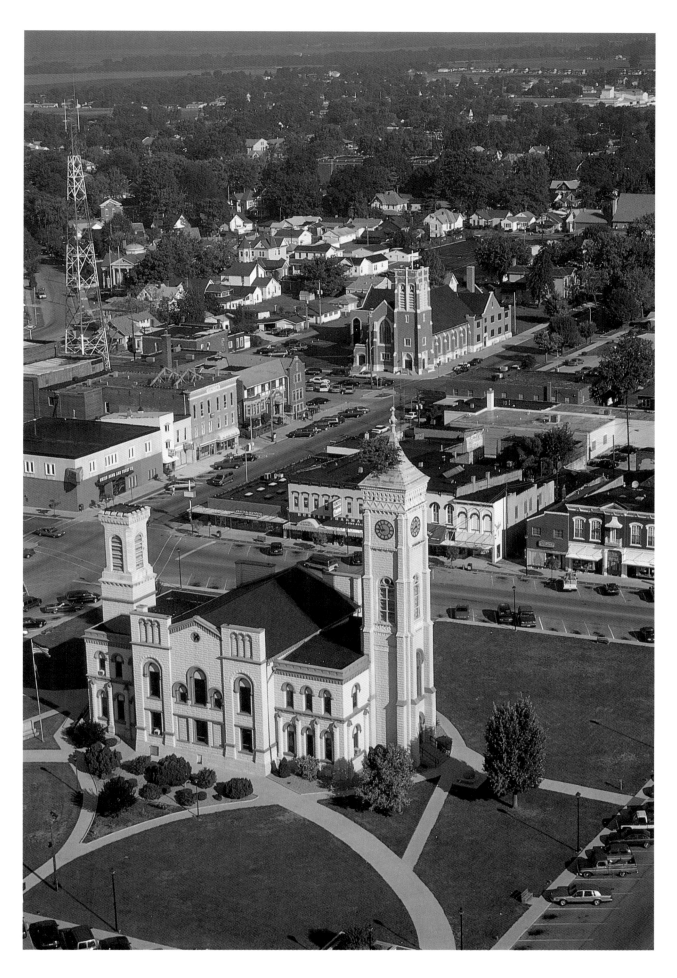

*A live tree growing out of the Decatur County Courthouse clock
tower in downtown Greensburg.*

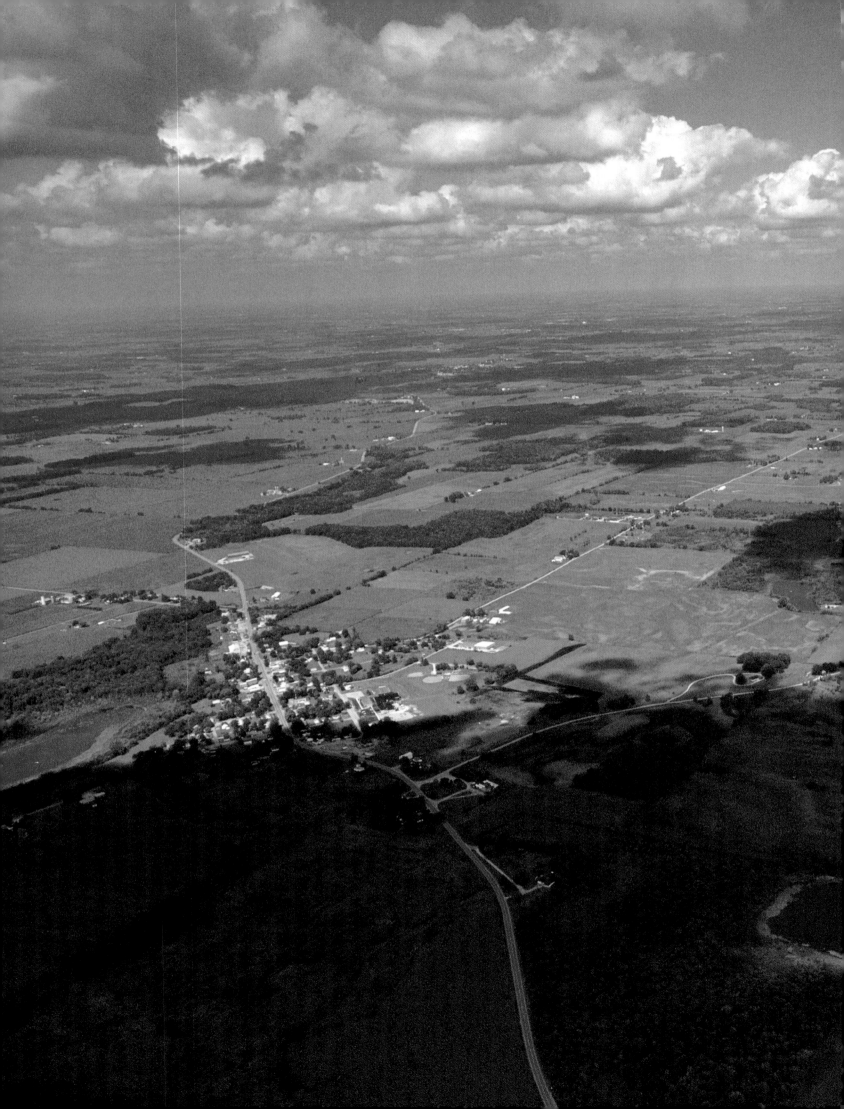

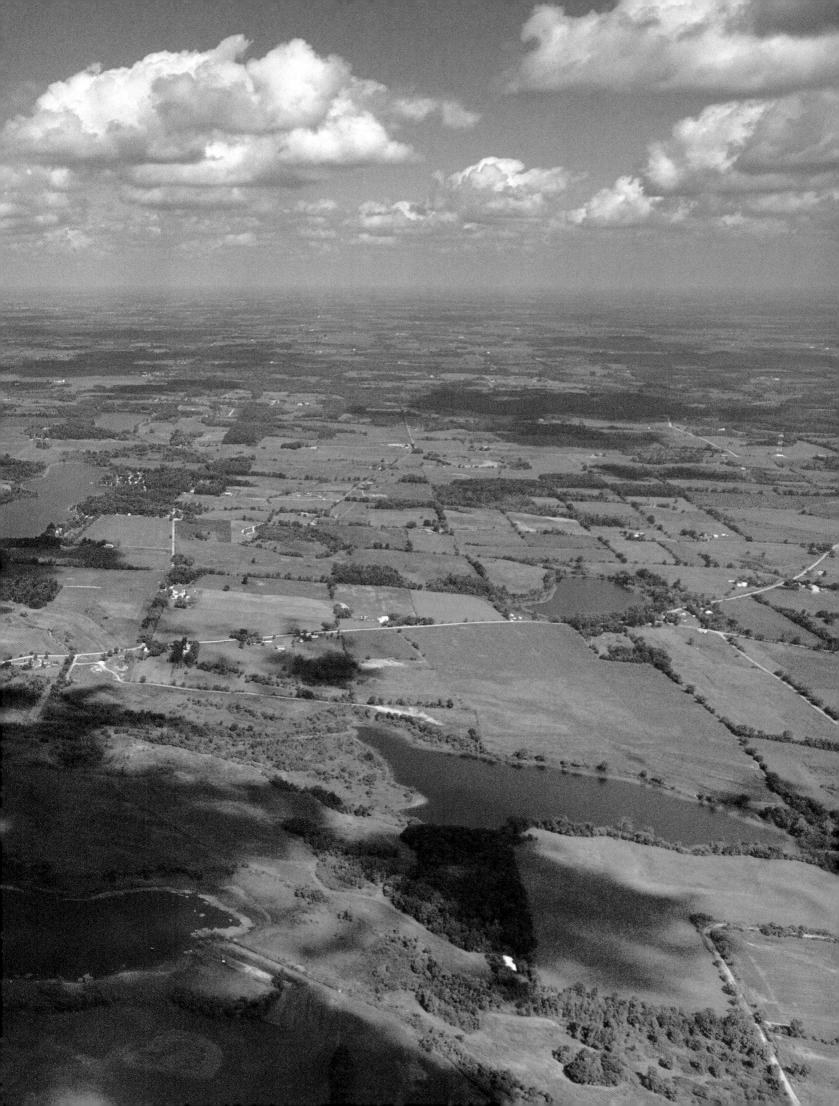

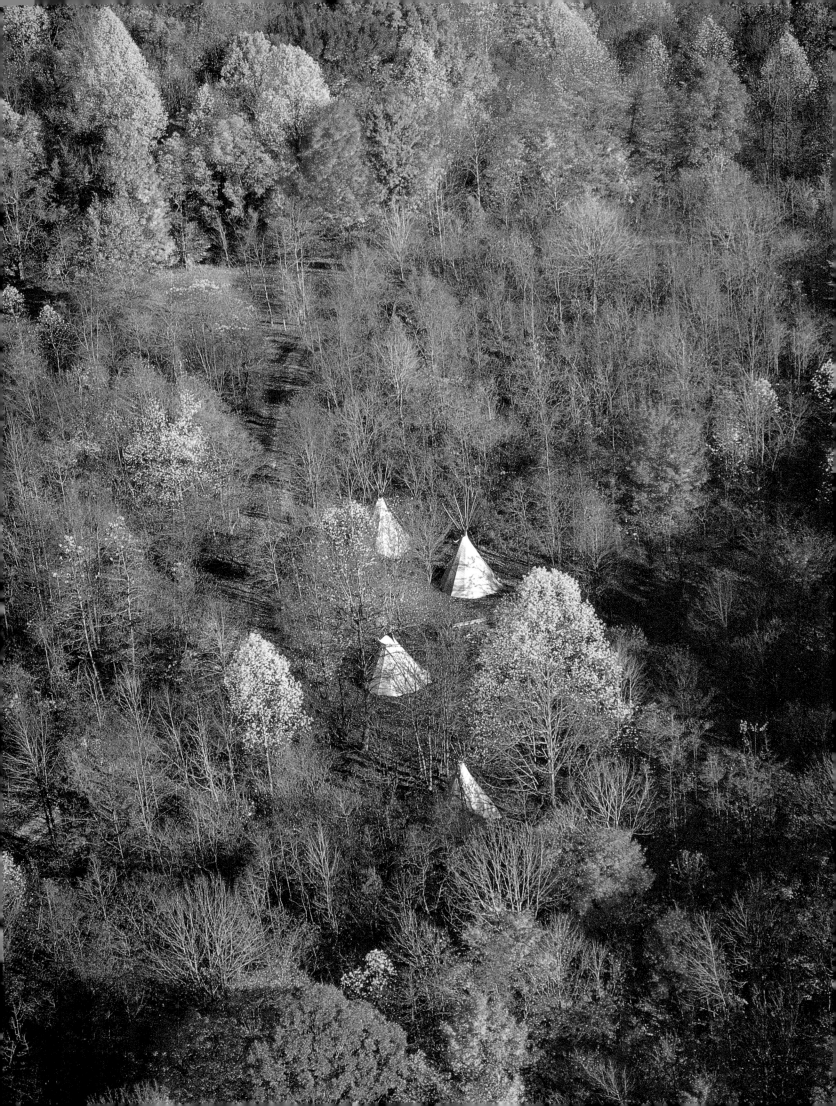

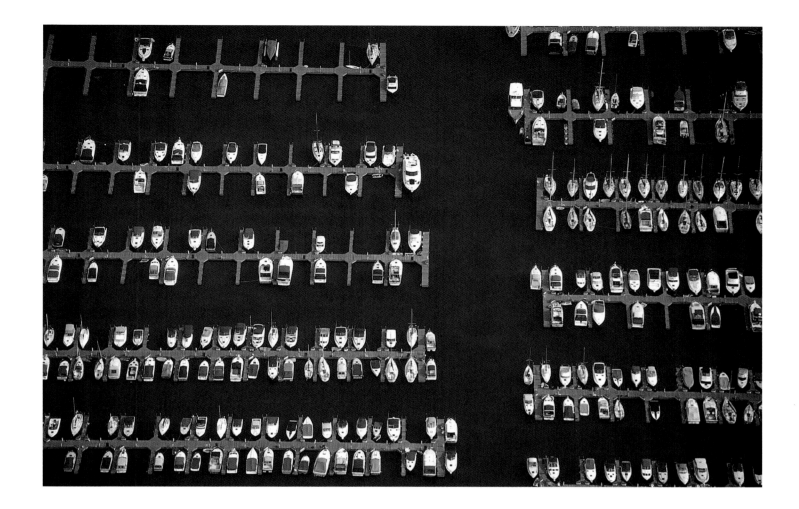

*Tepees now shelter campers at the Belmont
Girl Scout Camp, Brown County.*

✳

*Pleasure boats docked at the Hammond
Marina on Lake Michigan, Lake County.*

PRECEDING SPREAD: *Lakes and the shadows
of passing clouds dot the landscape near
the town of Wolf Lake in Noble County.
Upper Long Lake lies roughly in the center
of the photo.*

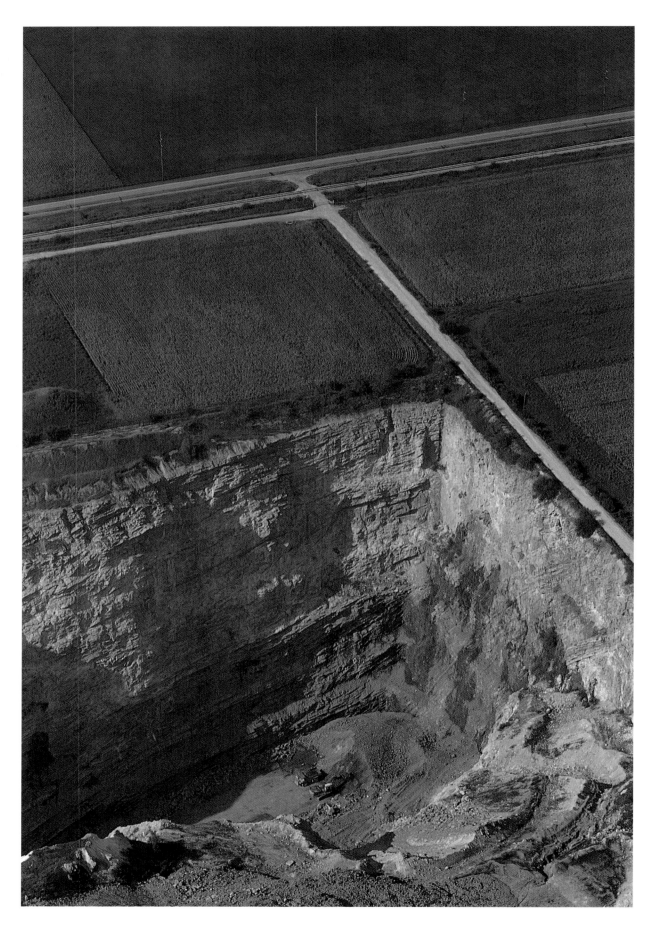

This large crushed stone quarry near Kentland in southern Newton County exposes one of Indiana's geological mysteries. The bedrock at this location is greatly deformed and fractured, suggesting an ancient cataclysm such as a meteorite impact.

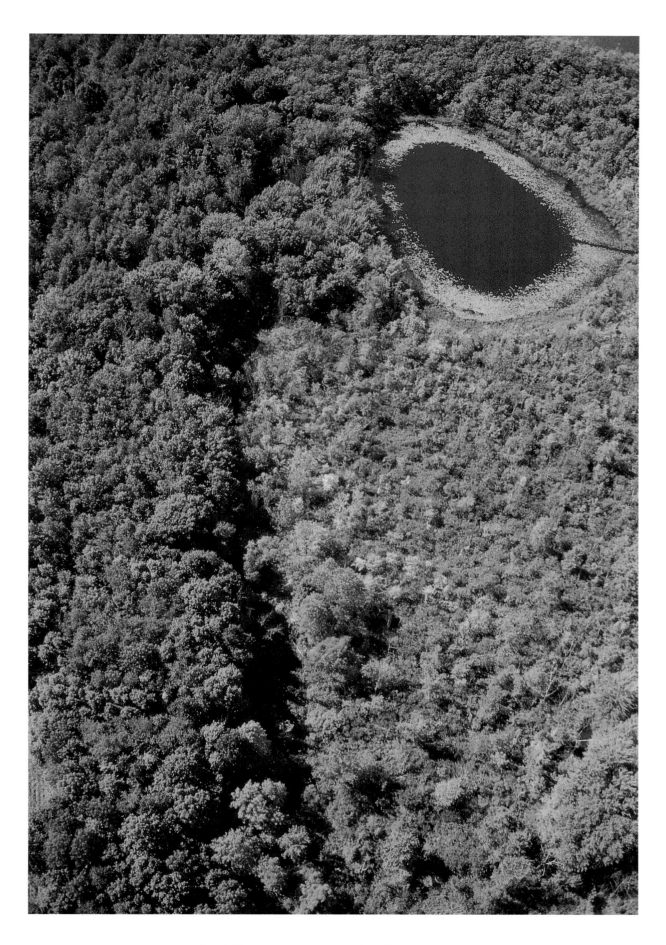

*Ringed with floating vegetation, Smith Hole in Lagrange County
is an undisturbed example of the many small glacial ponds
present in northern Indiana.*

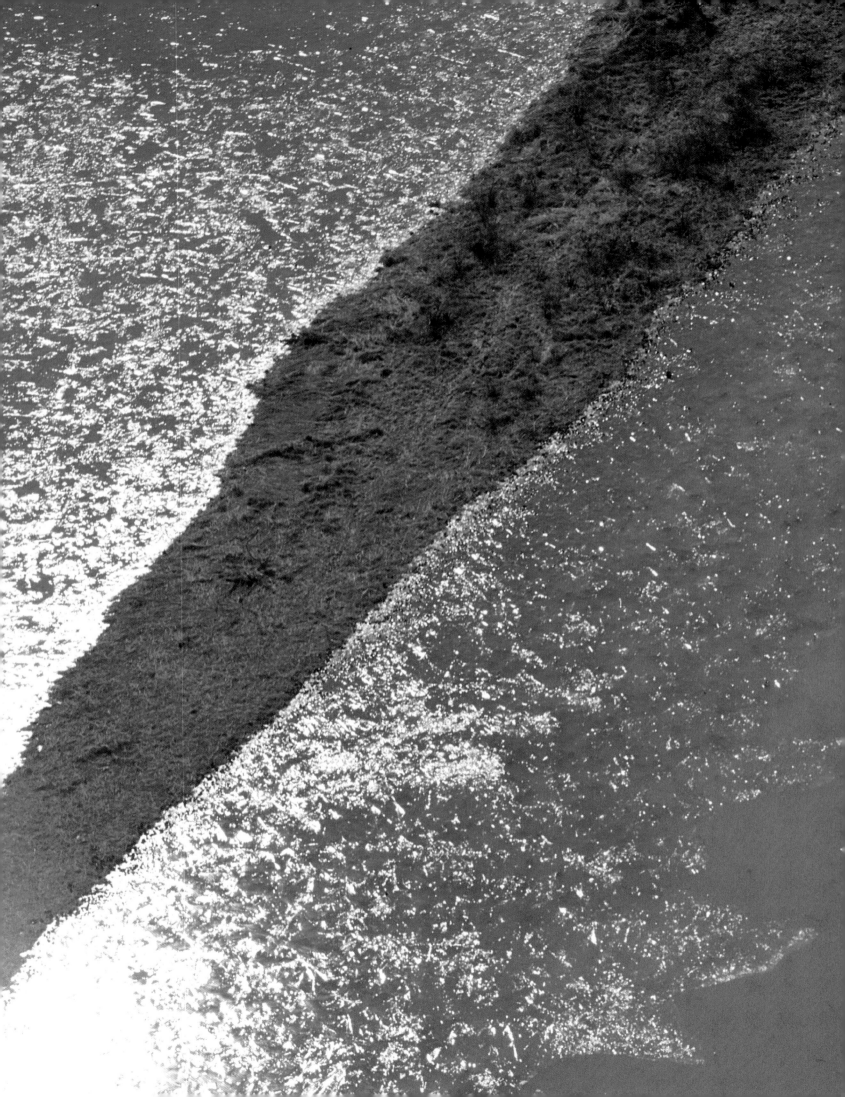

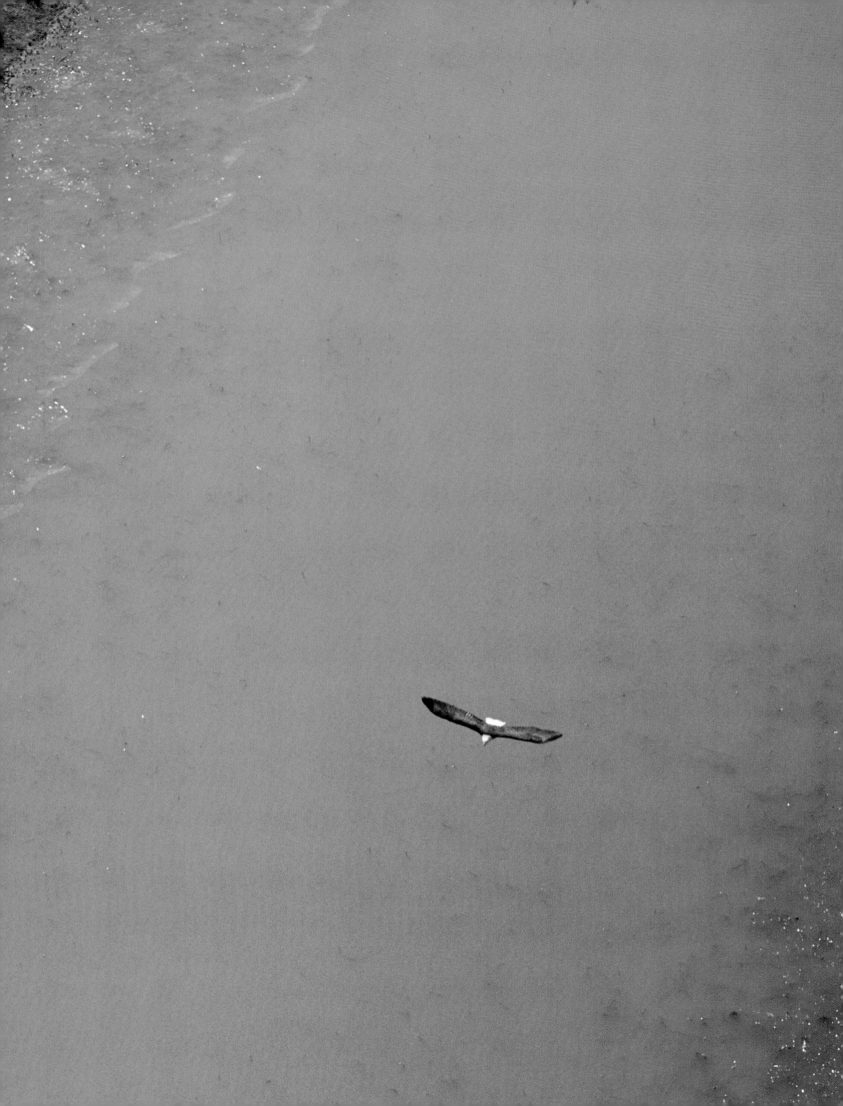

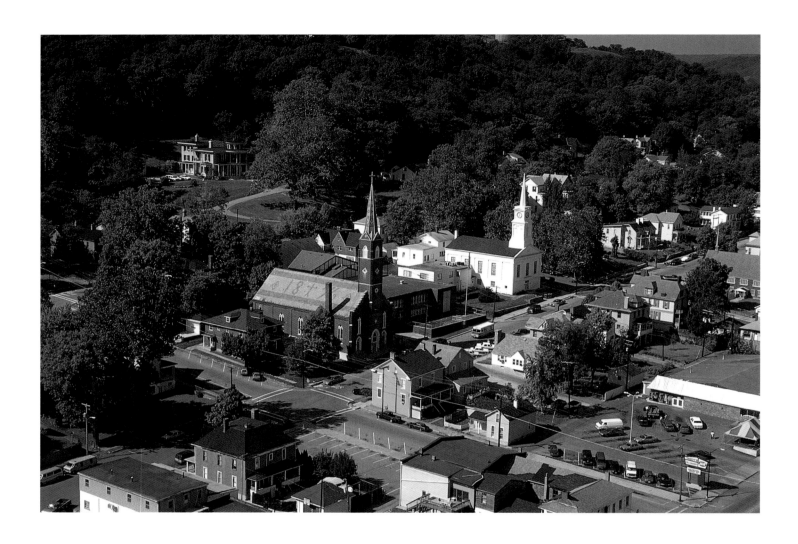

Hillforest Mansion in the background overlooks the town of Aurora on the Ohio River, Dearborn County.

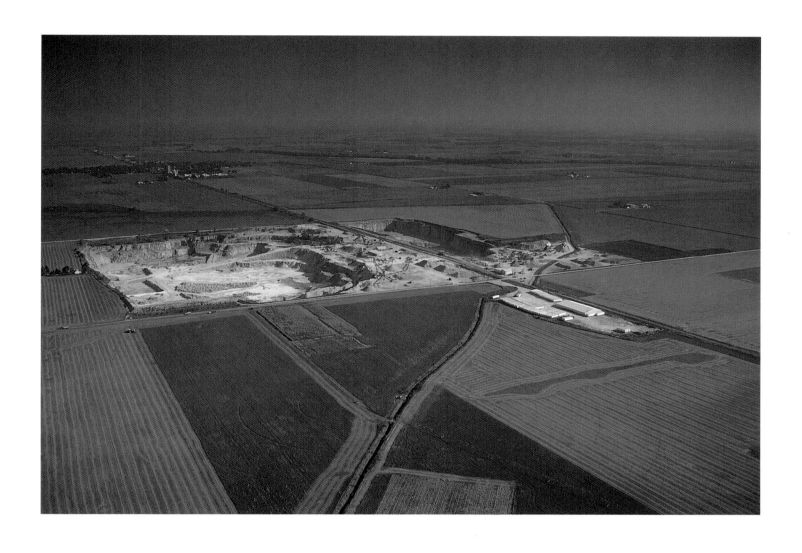

A crushed stone quarry straddles both sides of the old Monon Railroad south of Francesville, Pulaski County.

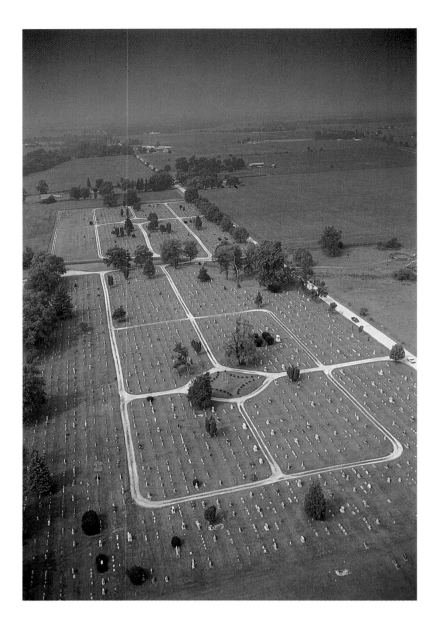

Each year hundreds of fans visit and leave offerings at the grave of James Dean, the "Rebel without a Cause," in Park Cemetery just north of his hometown of Fairmount, Grant County.

✳

"Five Points" intersection and the town of Monroe City in southeastern Knox County.

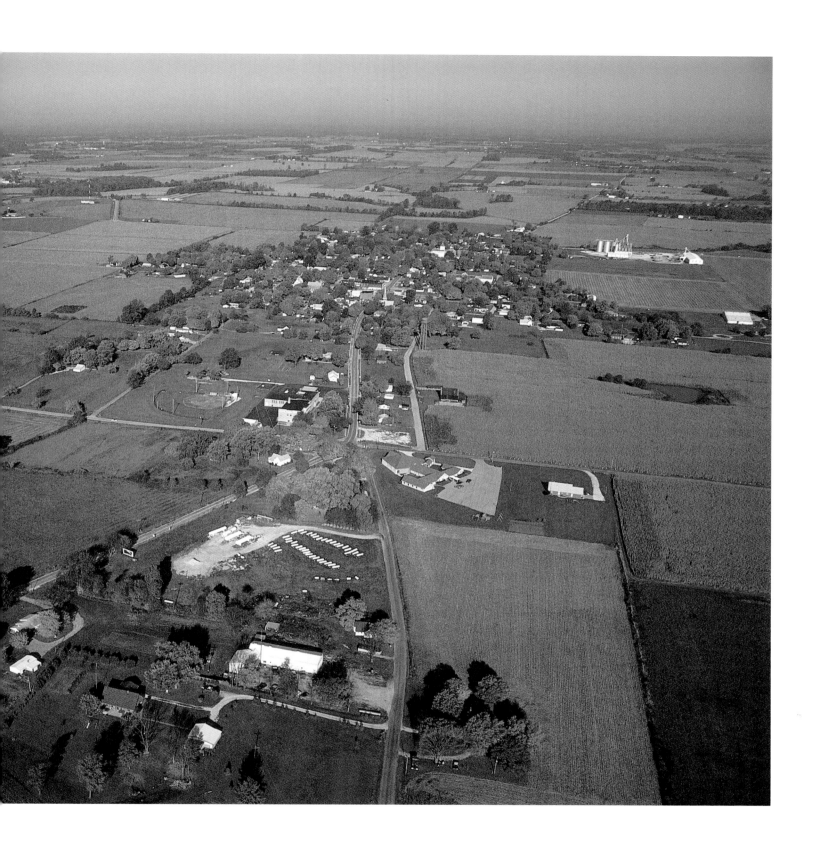

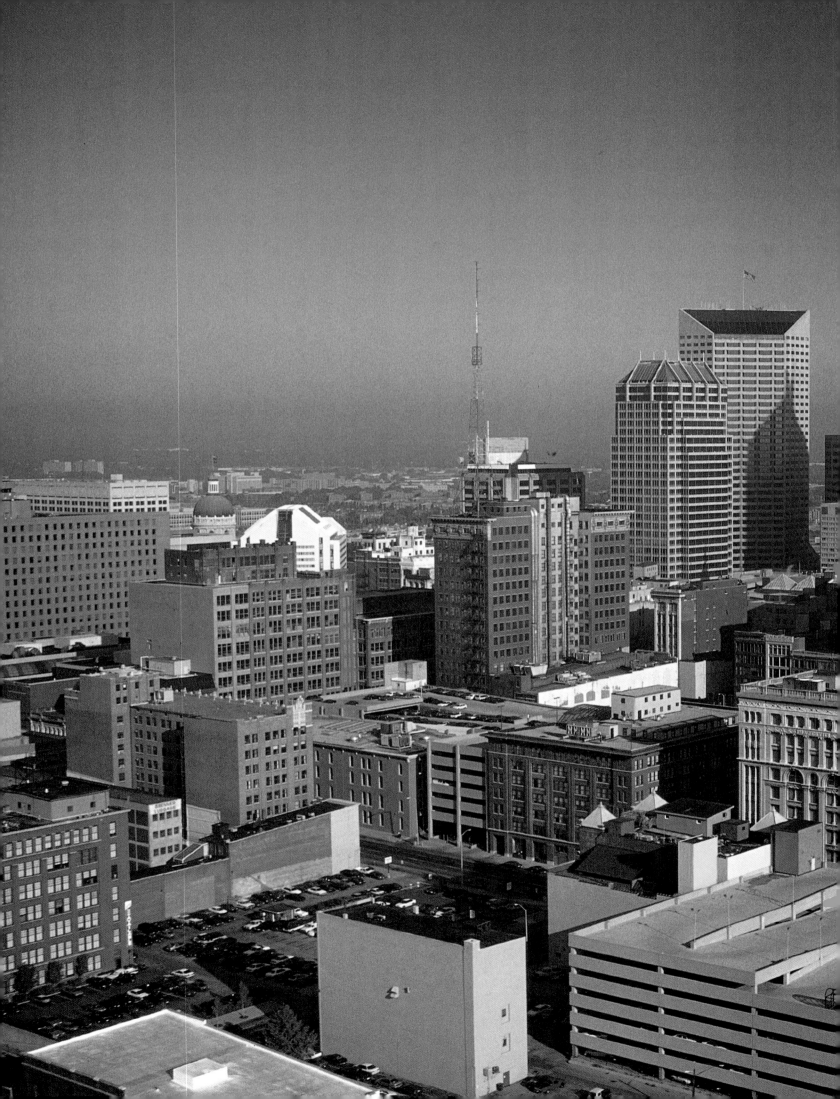

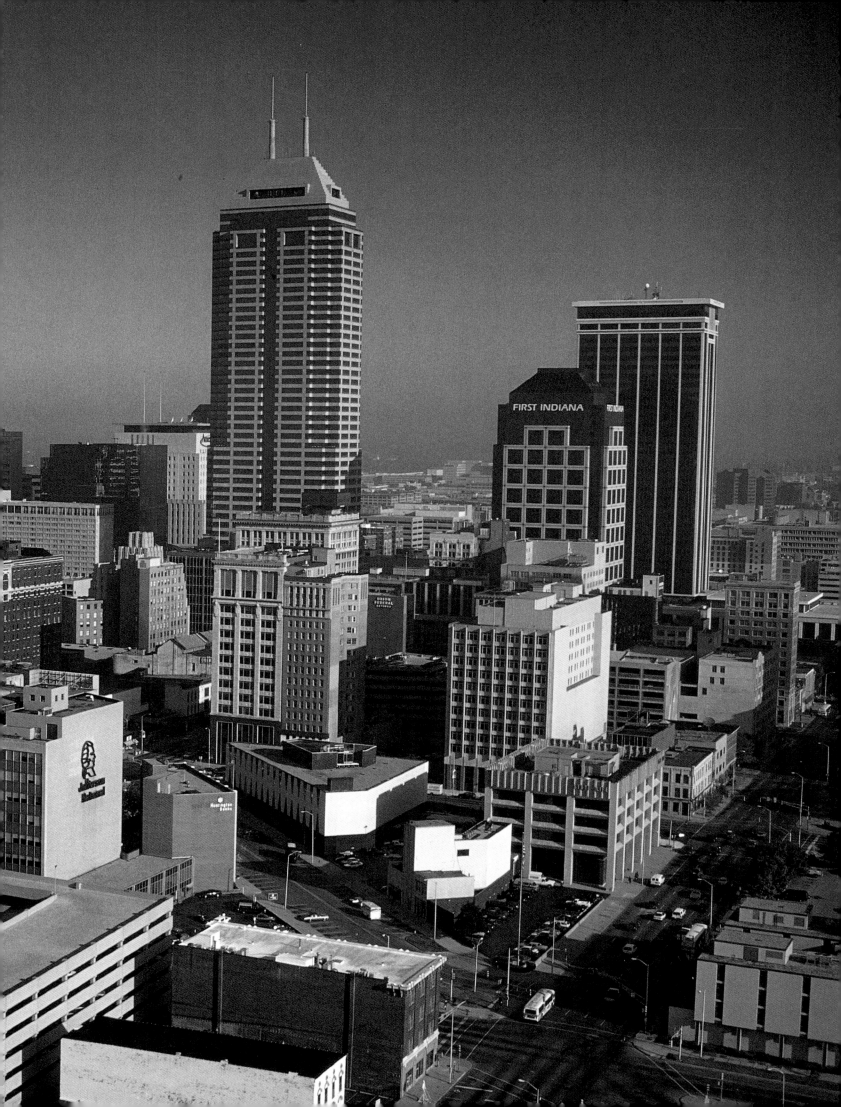

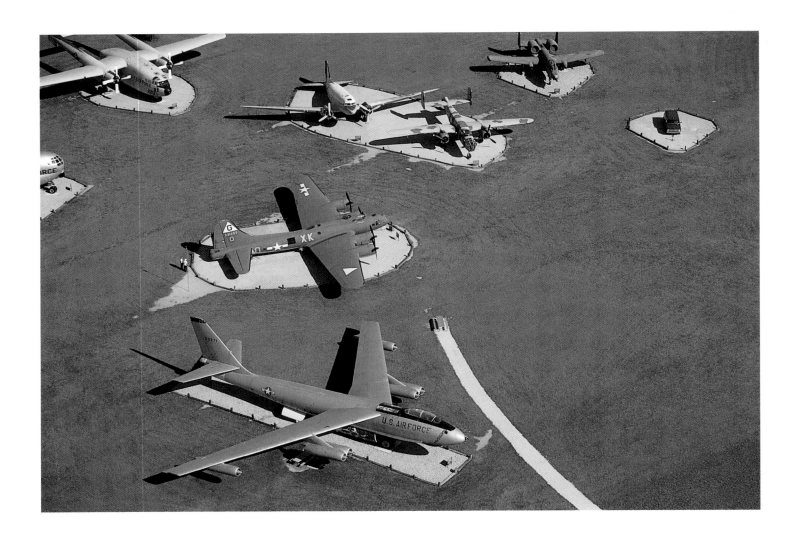

PRECEDING SPREAD: *Downtown Indianapolis occupies the geographic center of the state.*

Vintage warplane exhibit at Grissom Air Force Base in Miami County.

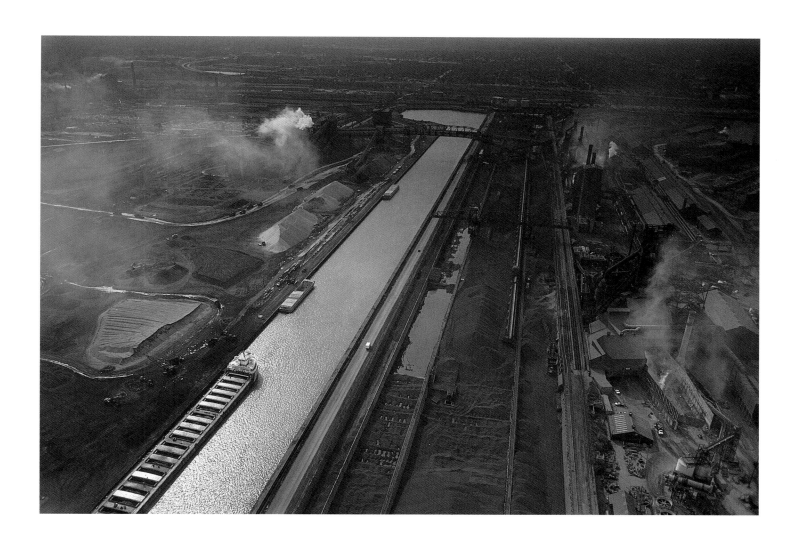

Industry lines the Gary Harbor shipping canal, Lake County.

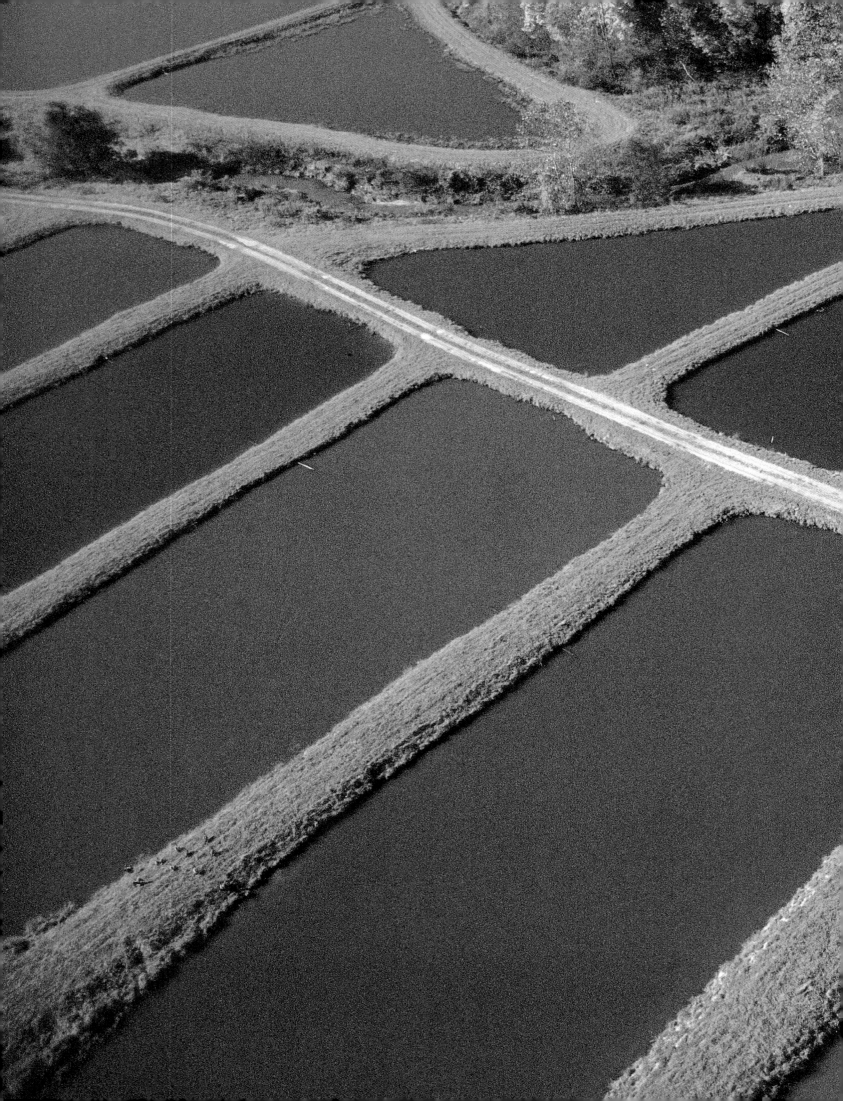

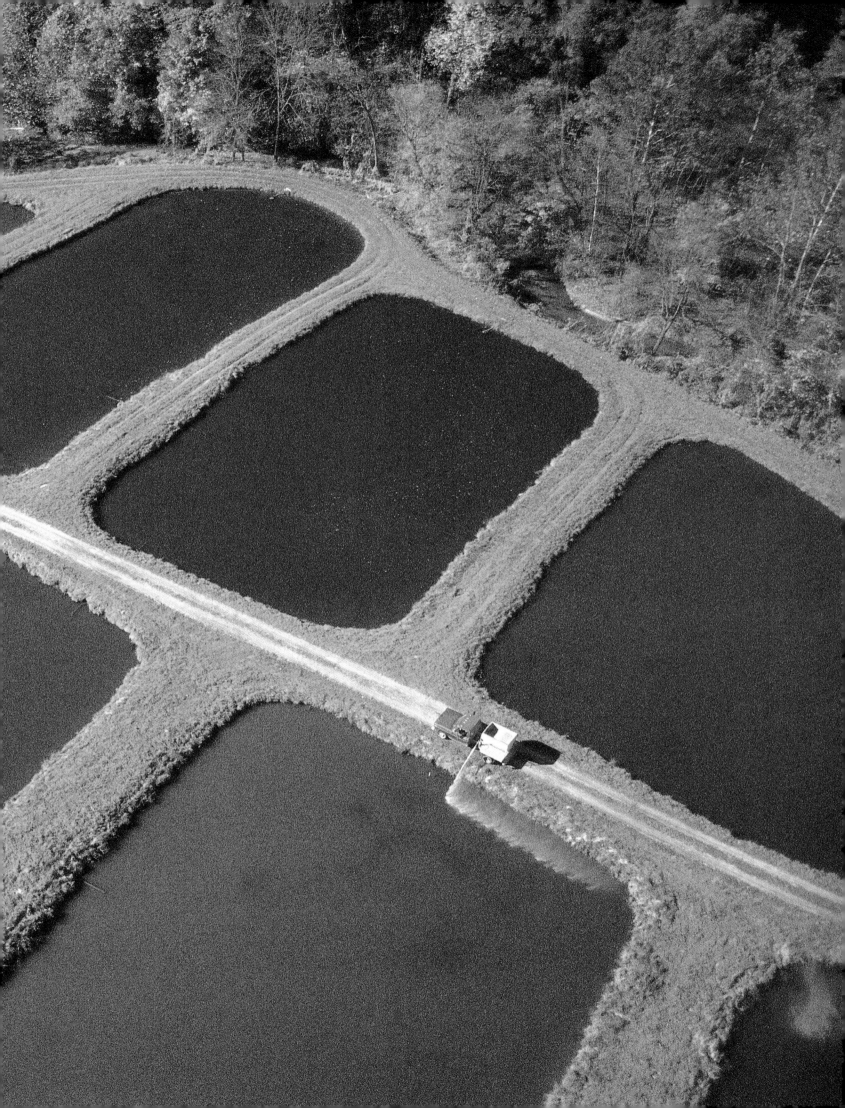

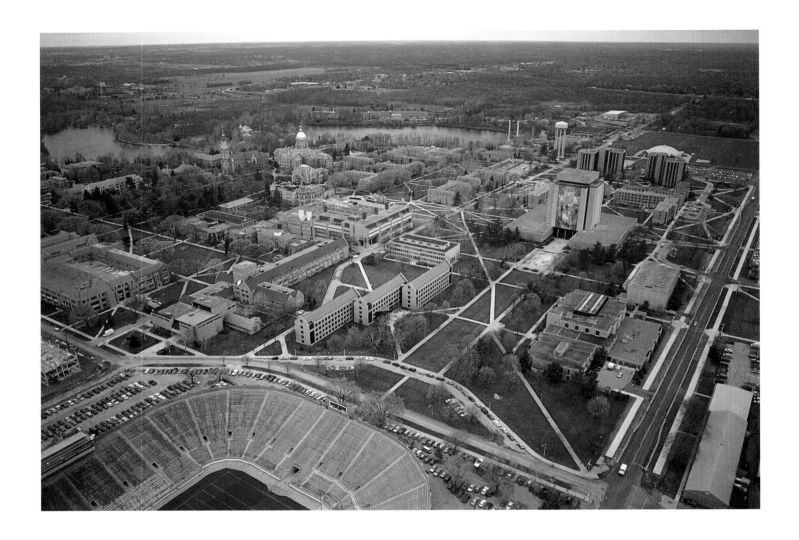

PRECEDING SPREAD: *Goldfish ponds at the Grassy Fork Fish Hatchery outside of Martinsville in Morgan County.*

The University of Notre Dame, founded in 1842 in South Bend, Saint Joseph County, is renowned for its academic standing and its football teams.

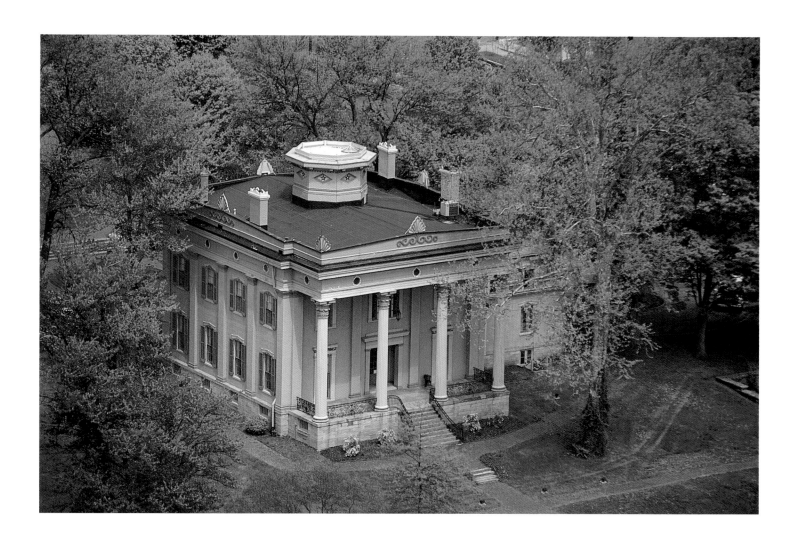

*The James F. D. Lanier State Historic Site
in Madison, Jefferson County, preserves
the antebellum residence constructed in
1840-44 by one of the state's early
successful businessmen and attorneys.*

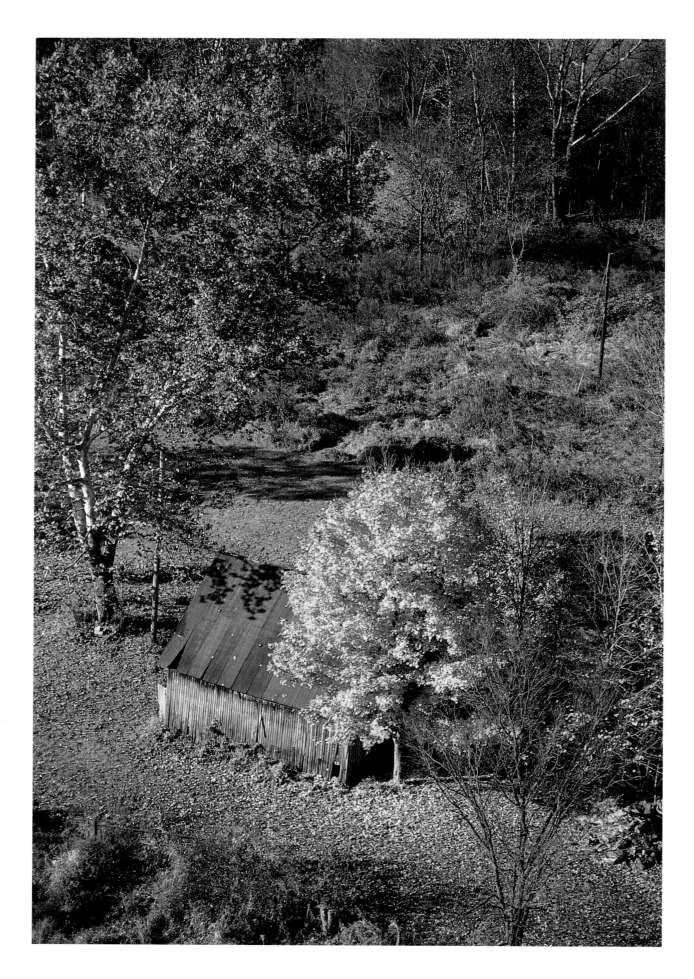

Autumn colors decorate a rural shed near Stone Head in Brown County.

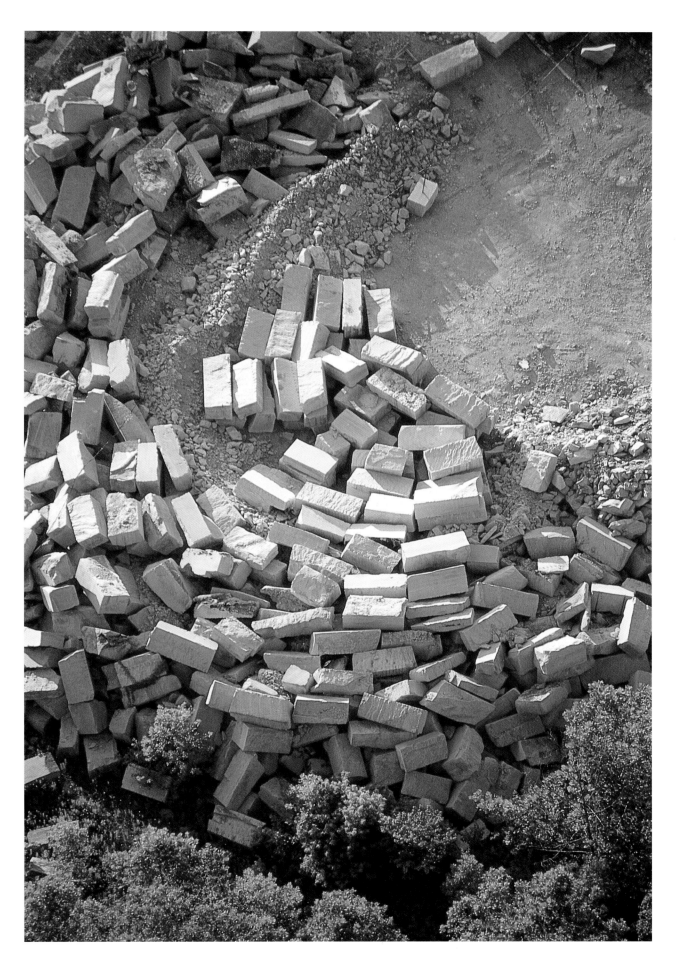

*Blocks of Salem limestone from quarries in Lawrence and Monroe
Counties have been used in constructing buildings nationwide.*

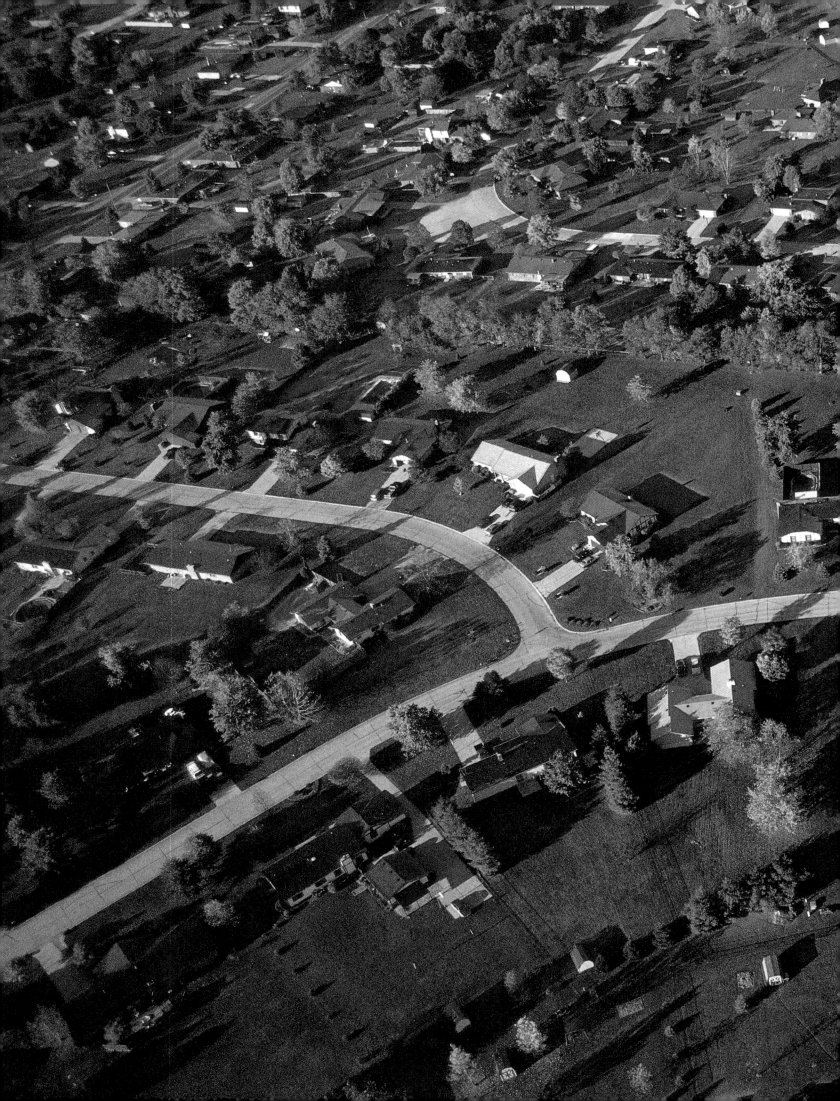

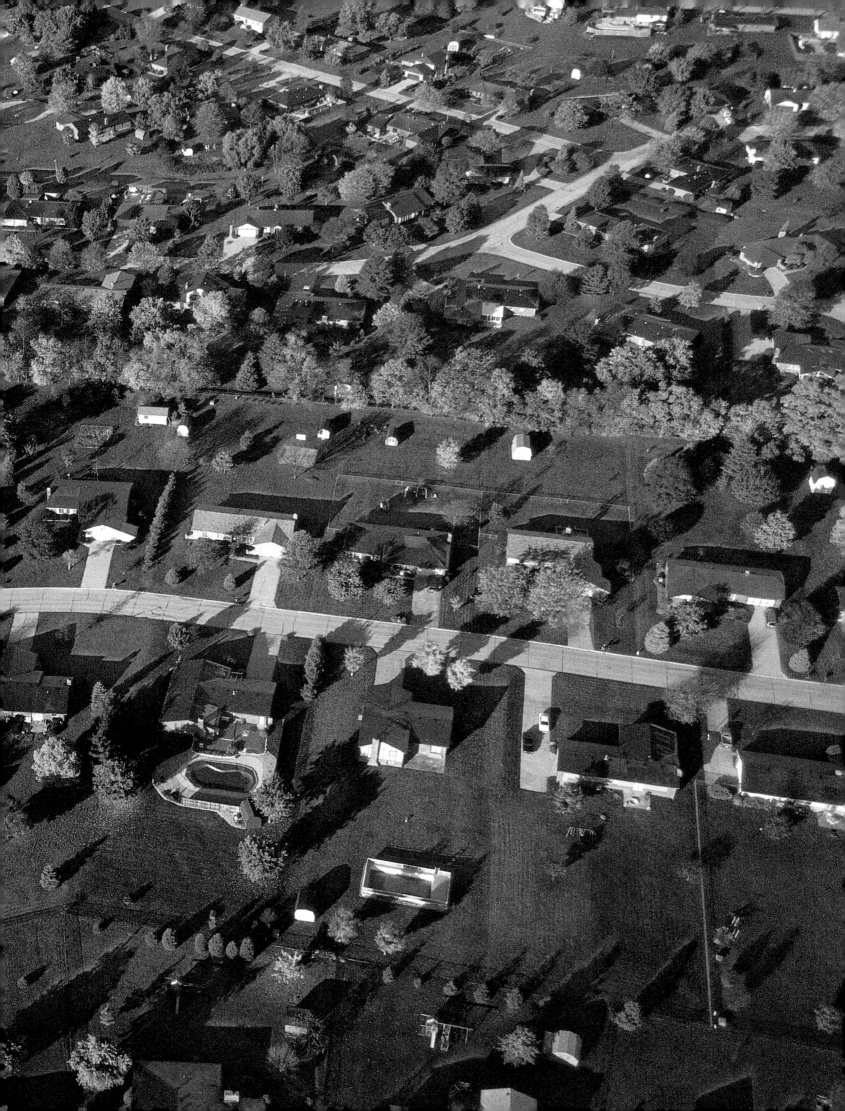

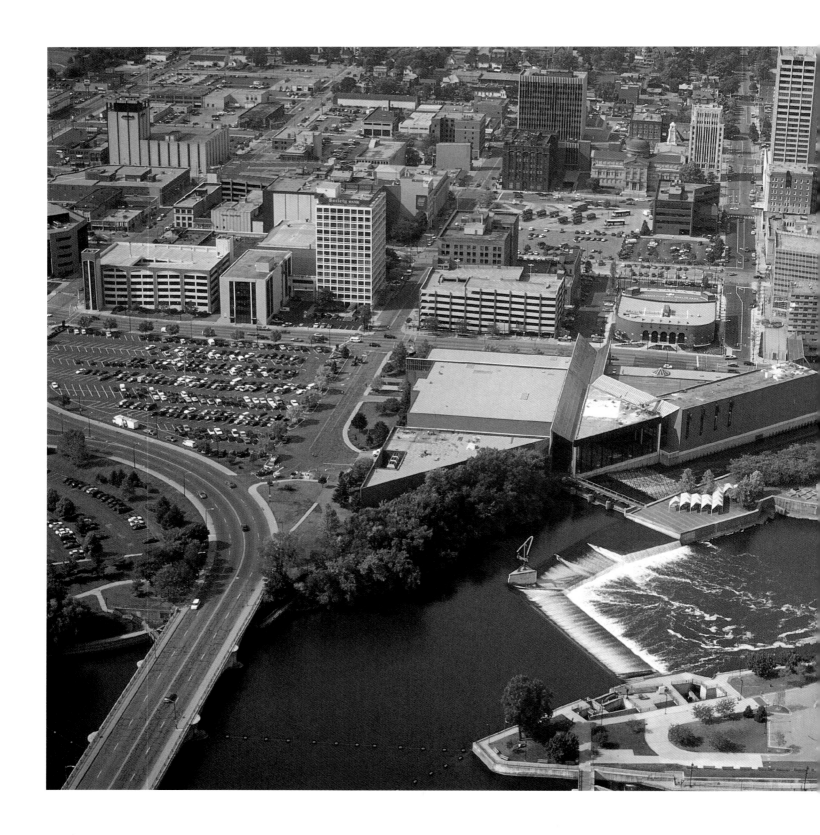

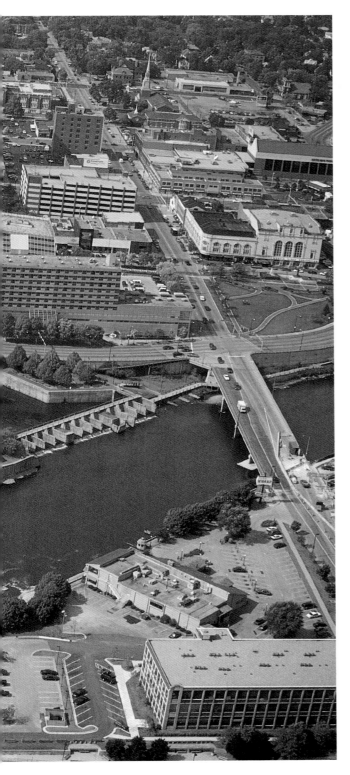

Century Center looks out on the Saint Joseph River and Island Park in downtown South Bend, Saint Joseph County.

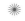

Patterns formed by earth-moving equipment signal the fast pace of development west of Bloomington in Monroe County.

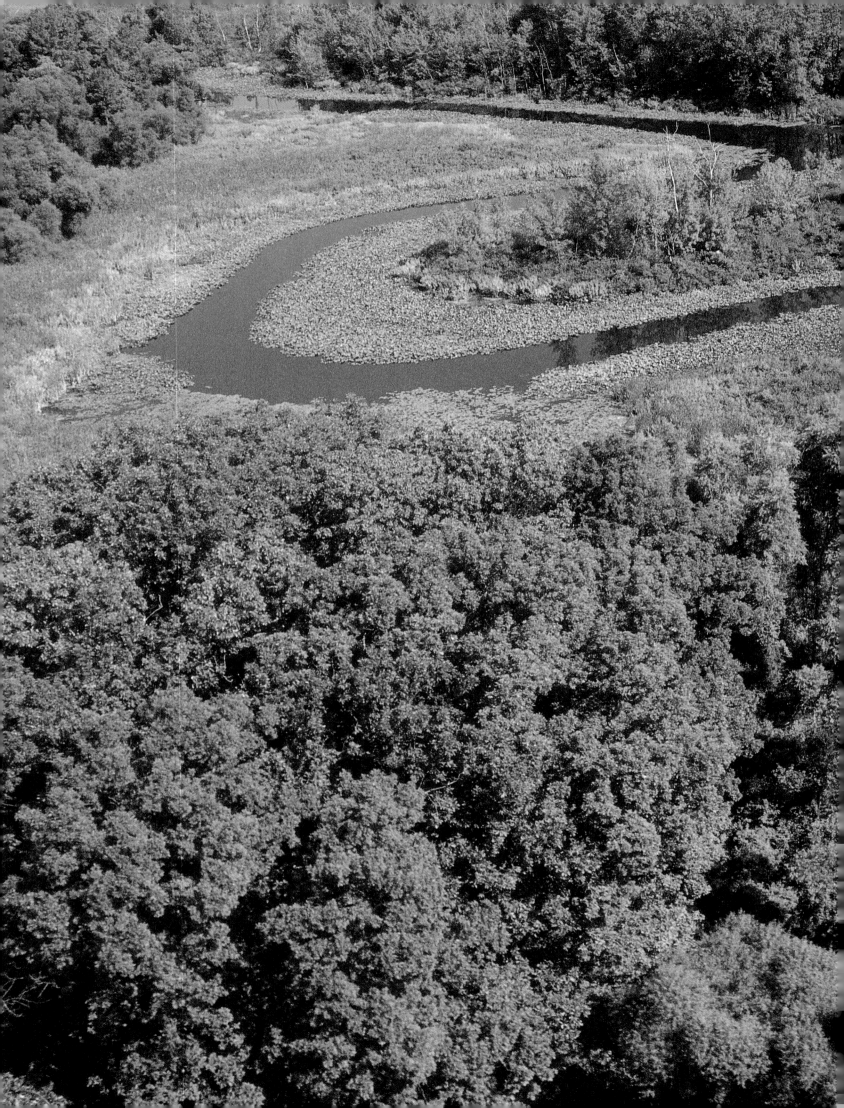

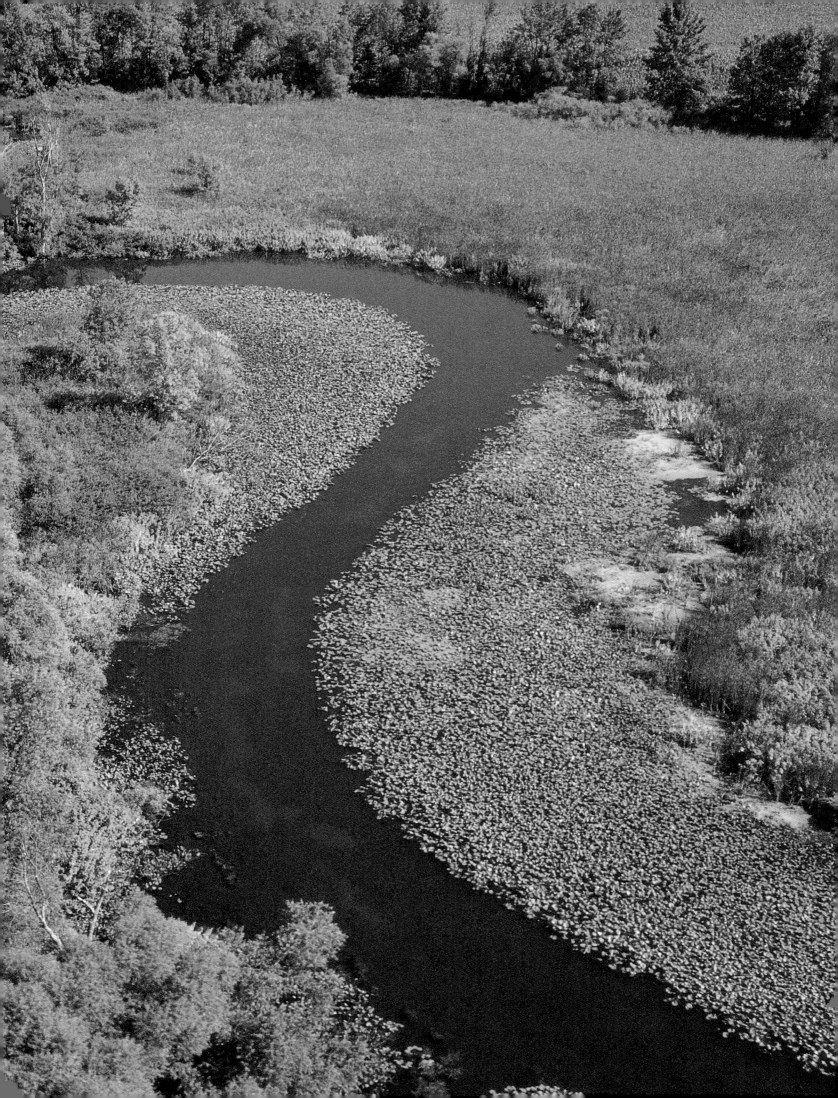

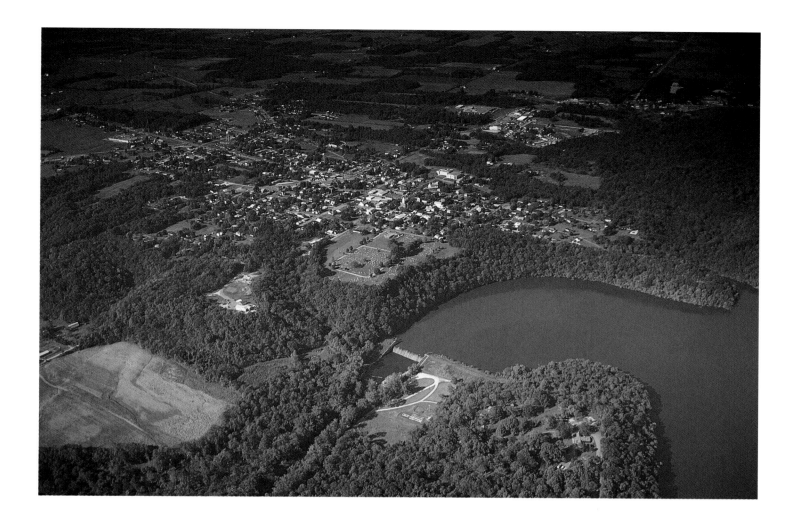

Christmas tree nursery in Saint Joseph County.

❋

With its 230-acre lake, Versailles State Park is
the second-largest state park in Indiana;
it is located just outside the town of Versailles
in Ripley County.

PRECEDING SPREAD: *Grassy Creek is a winding
natural channel connecting Tippecanoe and
Sawmill Lakes in Kosciusko County.*

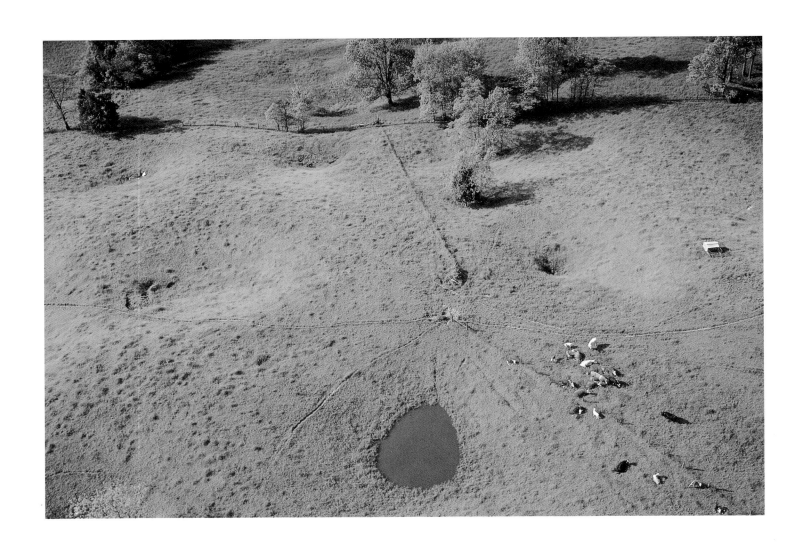

Sinkholes associated with limestone karst geology, three miles southeast of Quincy in northeast Owen County.

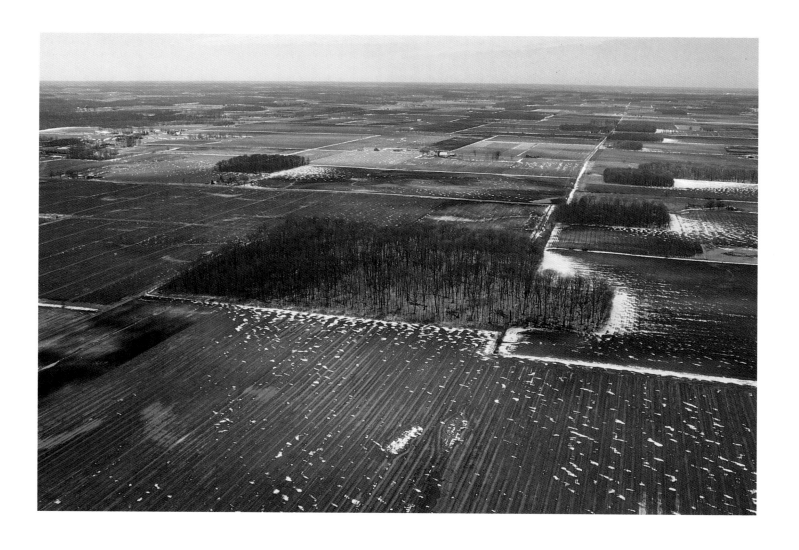

*Eunice Hamilton Bryan Nature Preserve, a
29-acre remnant old-growth woods, located
seven miles northwest of Frankfort in Clinton
County, is an island of natural vegetation
surrounded by a sea of agriculture.*

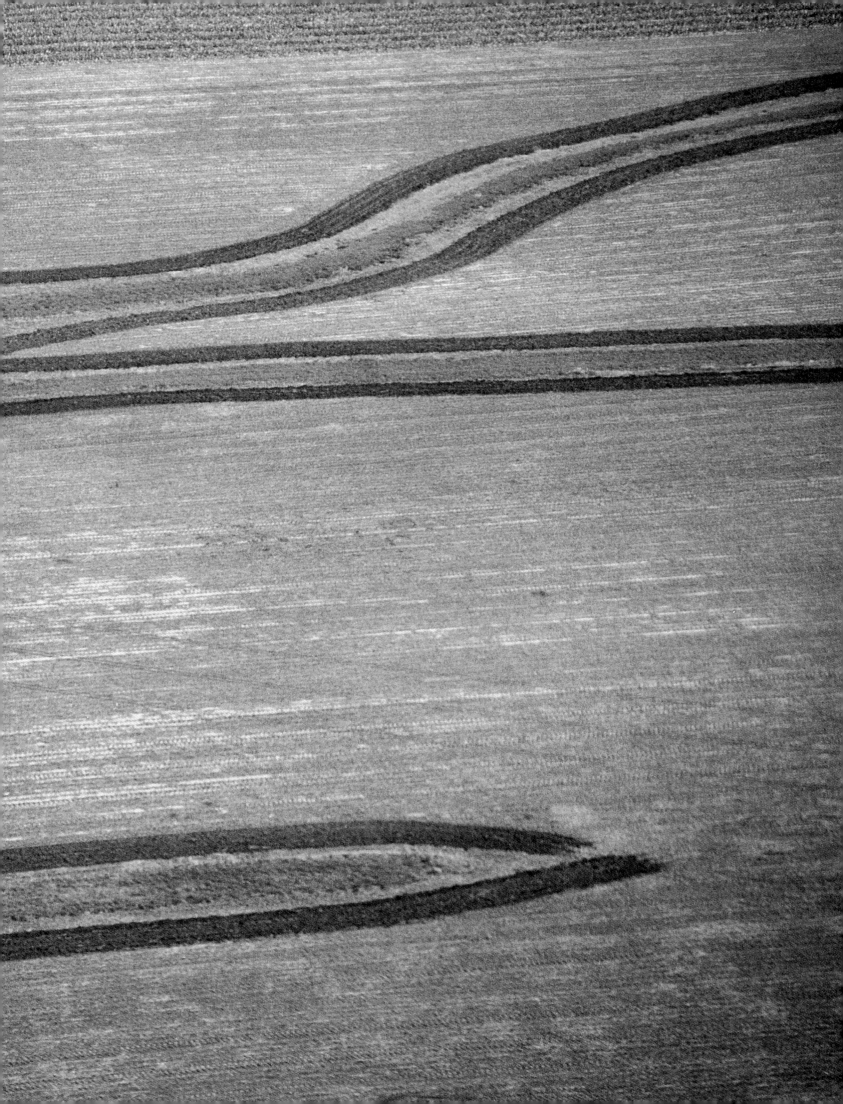

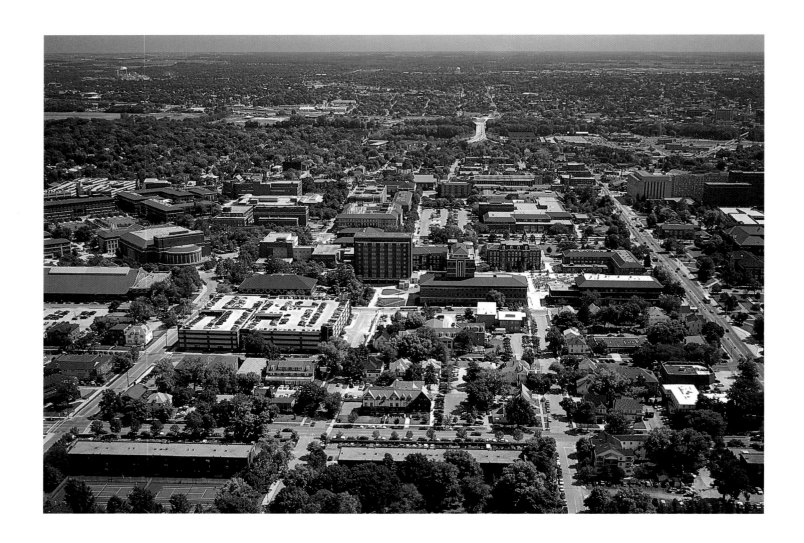

PRECEDING SPREAD: *Grass corridors along drainage ways reduce soil erosion runoff in rural Putnam County.*

Founded in 1869—classes started in 1874 with thirty-nine students—Purdue University in West Lafayette, Tippecanoe County, has grown to become one of the nation's leading engineering and agricultural schools and now has an enrollment of over 30,000.

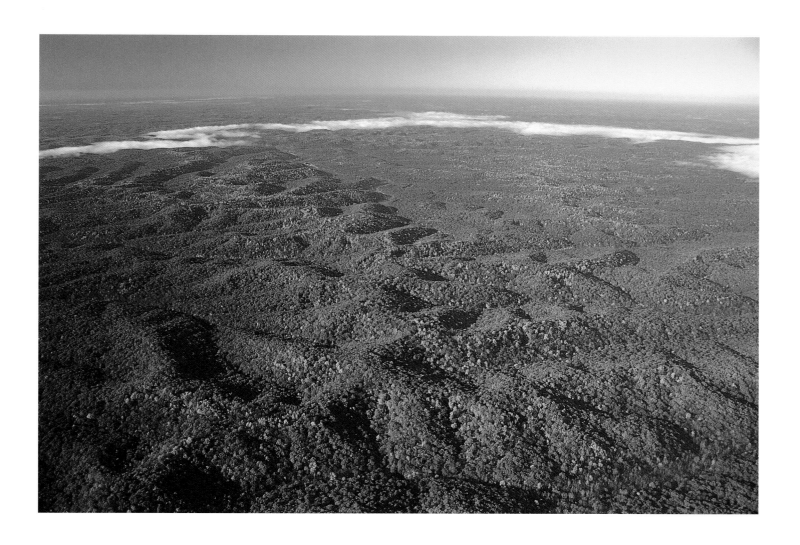

FOLLOWING SPREAD: *Light tower and elevated walkway at the entrance to the Michigan City Harbor on Lake Michigan, La Porte County.*

Dissected topography of Taylor Ridge, located in the back country of Brown County State Park.

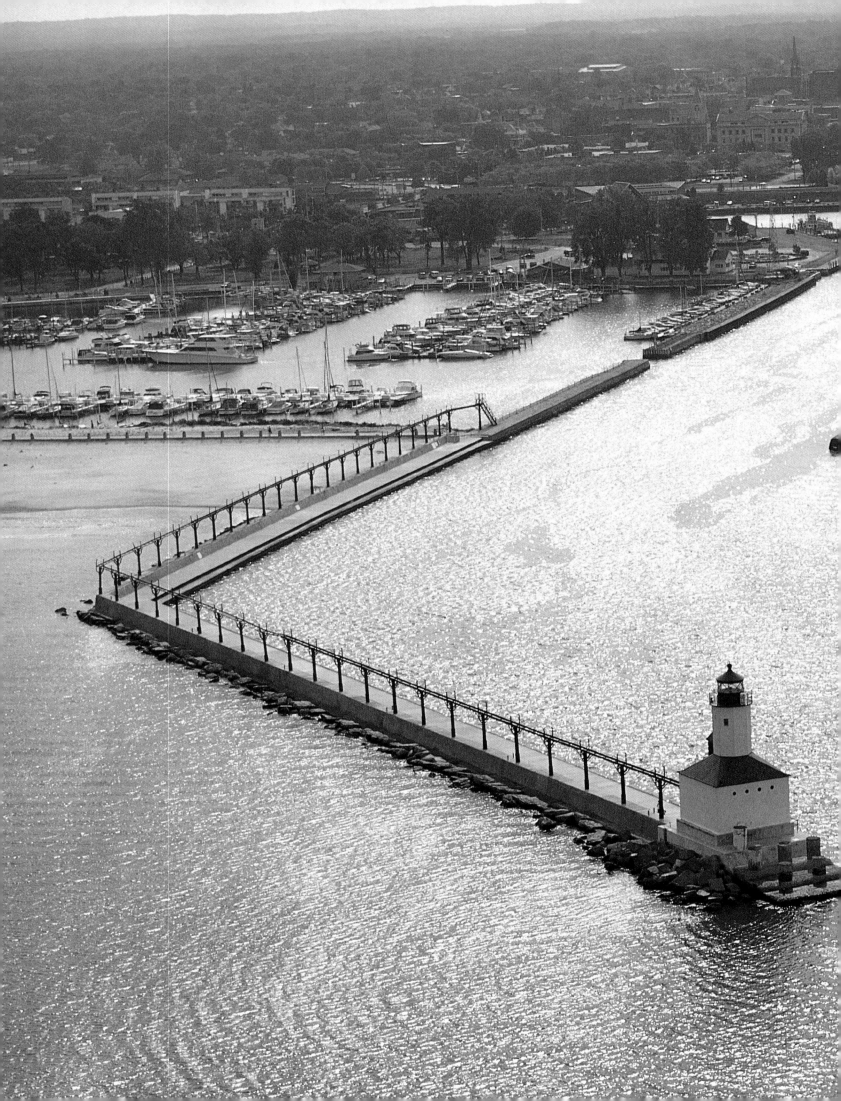

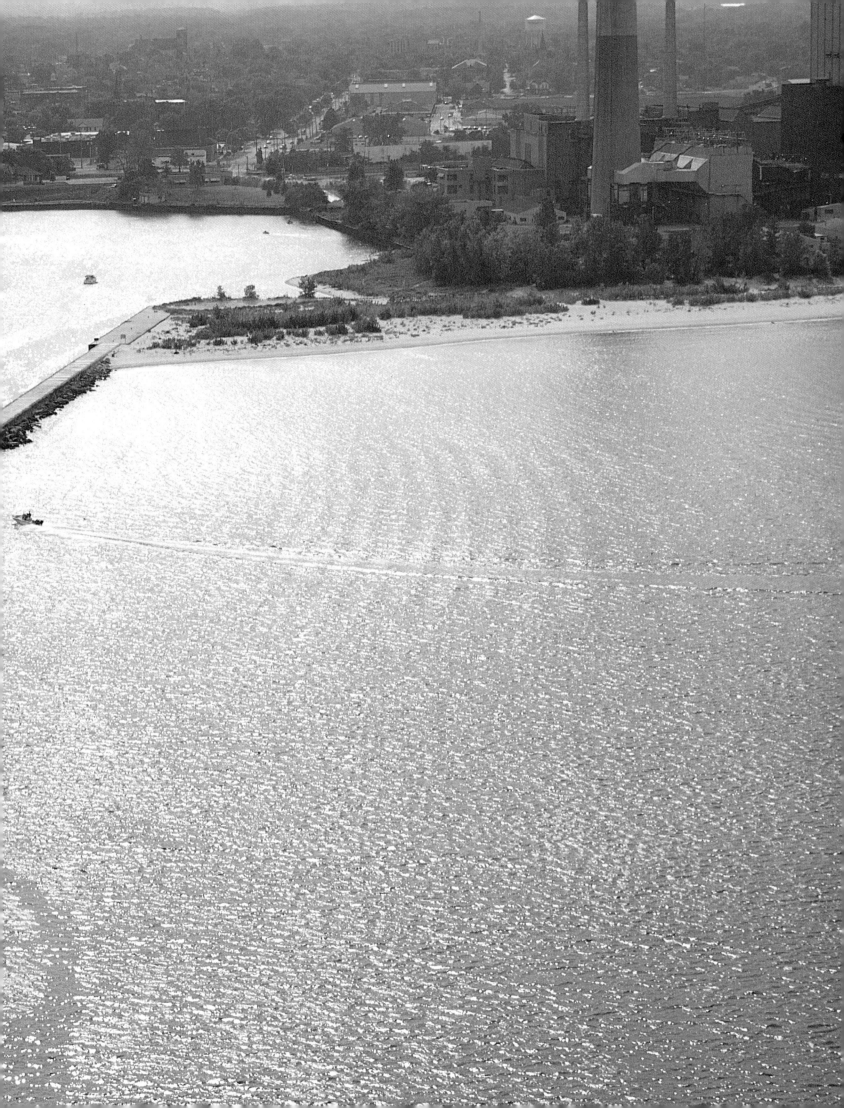

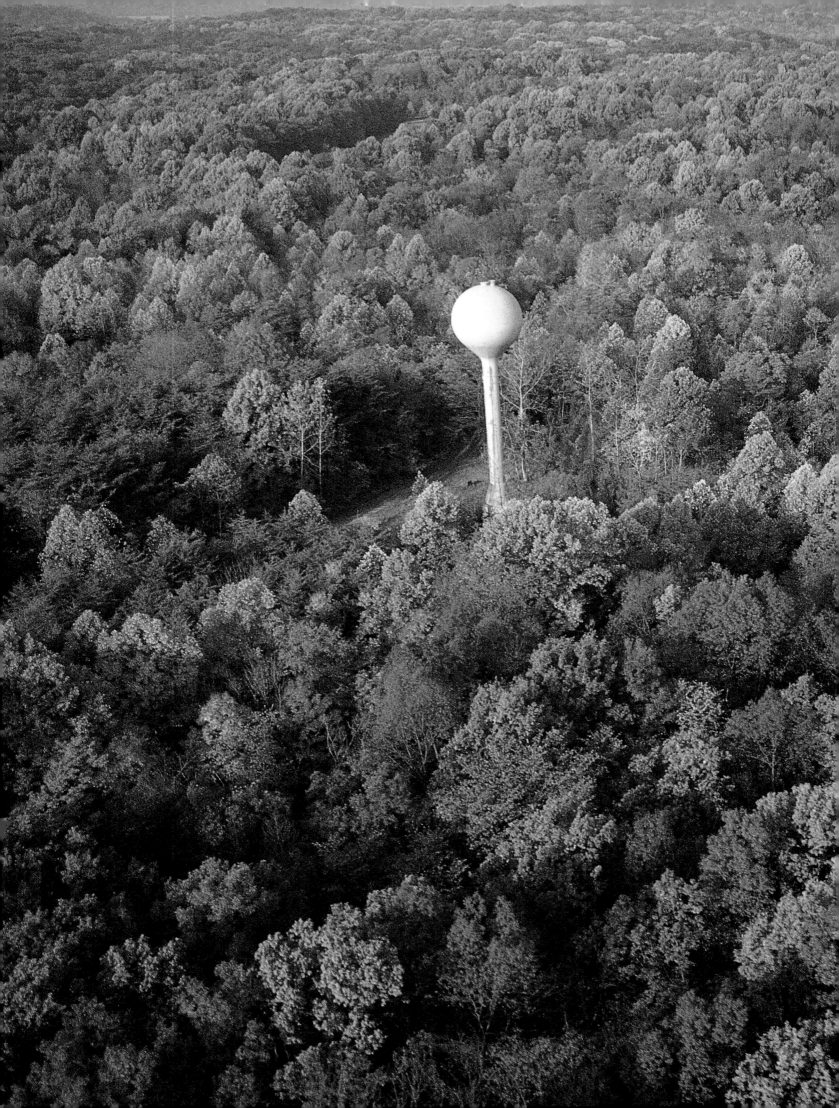

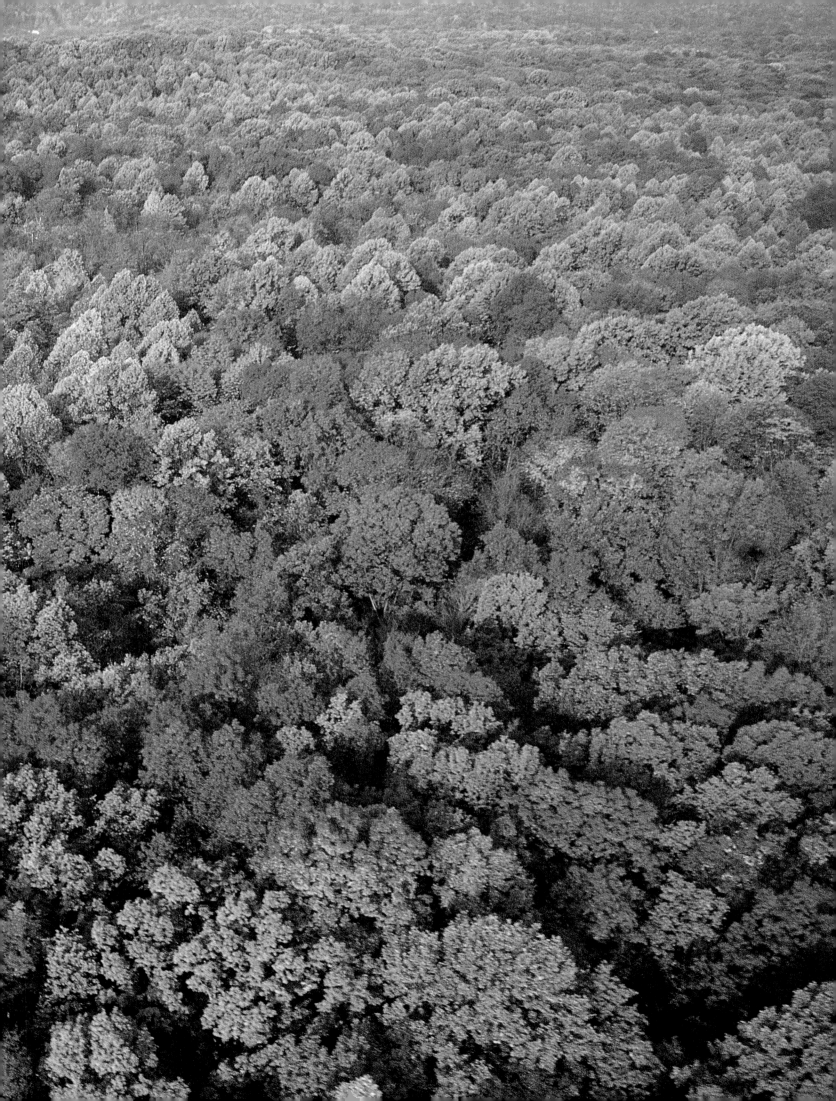

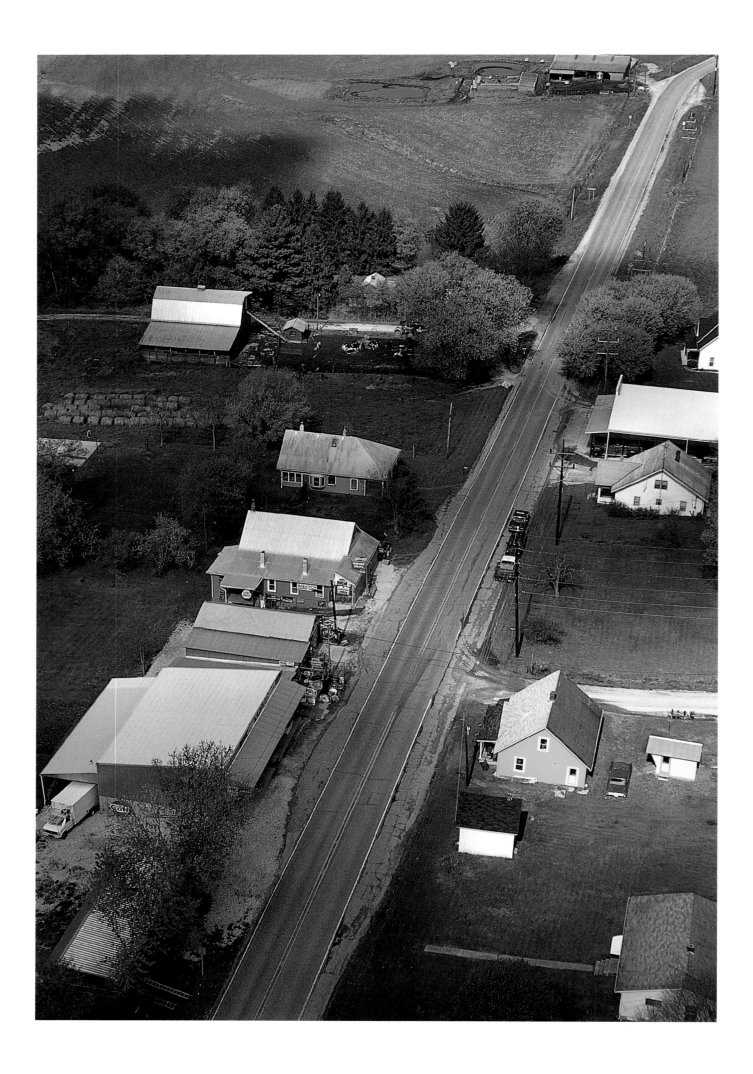

U.S. Route 150 passes by this eclectic collection of old signs in the hamlet of Chambersburg in Orange County.

✺

The Indiana Dunes National Lakeshore in Porter and Lake Counties boasts one of the most diverse assemblages of plant species found in Indiana or in any unit of the National Park System, as exemplified by this meeting of dune, forest, and marsh.

PRECEDING SPREAD: *Autumn colors paint McCormick's Creek State Park in Owen County. Originally established as a "sanitarium," or health resort, in 1888, it subsequently became Indiana's first state park in 1916.*

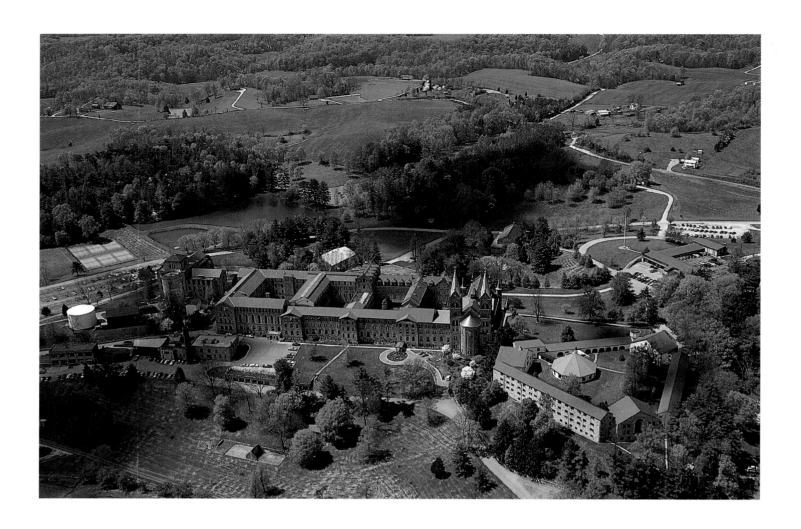

The Benedictine archabbey and monastery
at Saint Meinrad lends some Old World
character to the Spencer County countryside.

The relatively clear water of the Tippecanoe
River mixes with silt-laden water of the
Wabash River at their confluence in
northeastern Tippecanoe County.

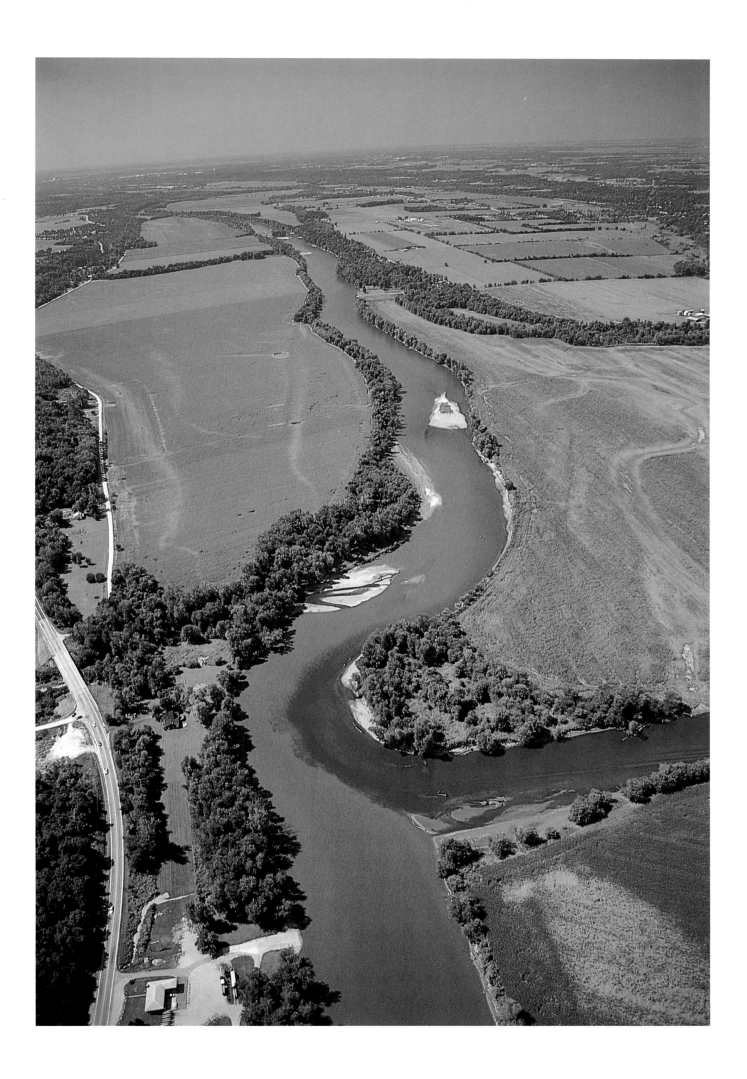

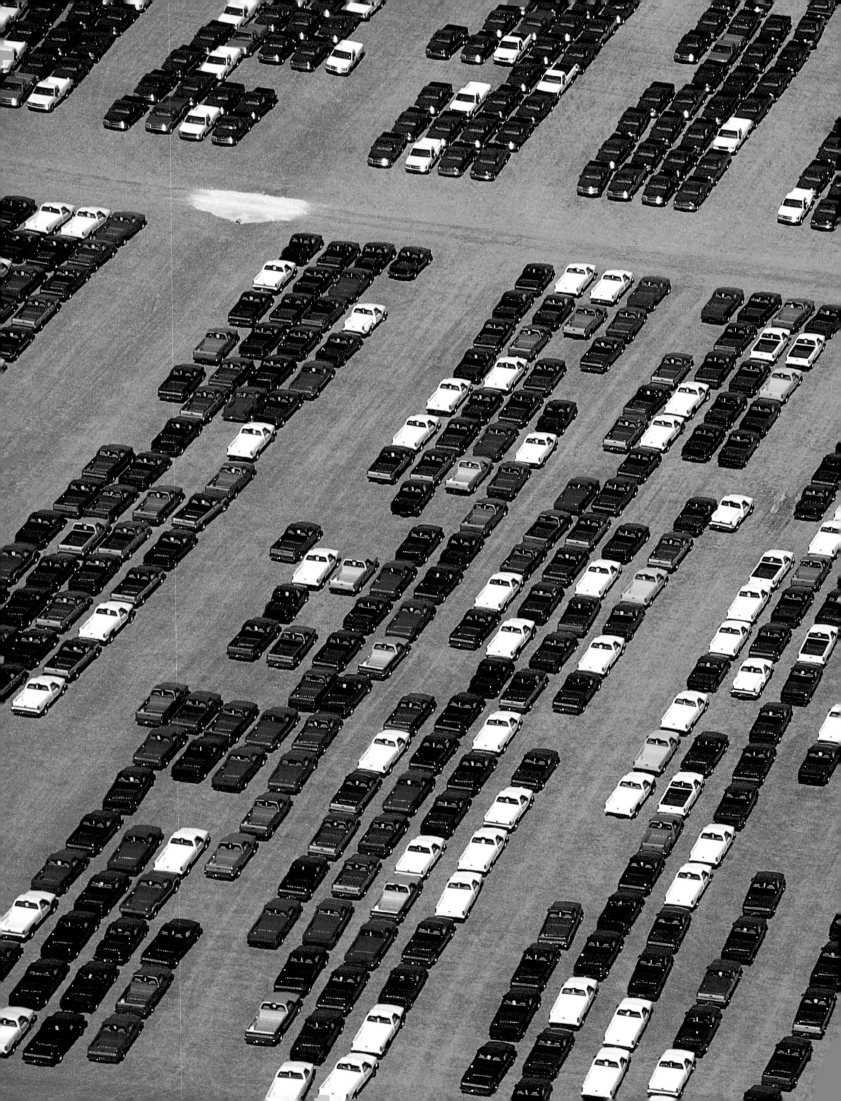

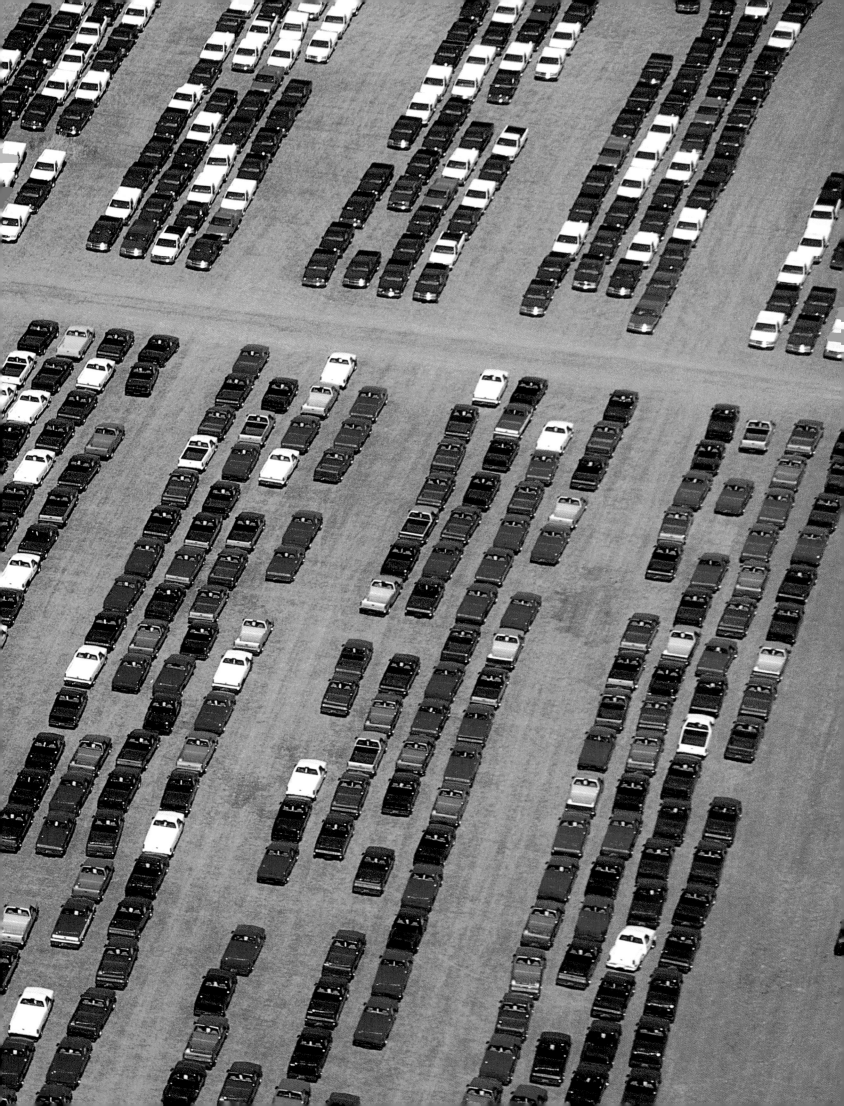

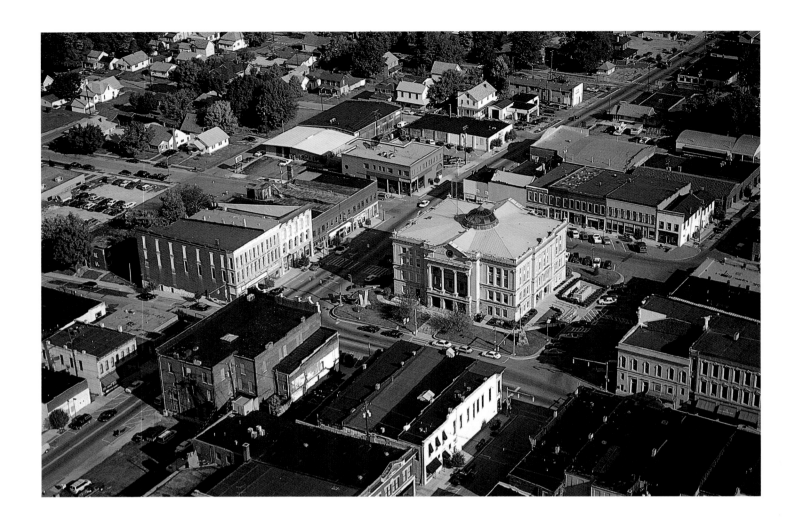

PRECEDING SPREAD: *Trucks awaiting*
transport outside the General Motors
assembly facility southwest of
Fort Wayne, Allen County.

A captured German V-1 rocket, or "buzz
bomb," from the Second World War
decorates the courthouse square in
downtown Greencastle, Putnam County.

✳

Cockeyed farm fields such as these, two
miles east of Decker near the White River,
are evidence of the very early French
settlement of portions of Knox County,
predating the more common north-south,
east-west survey grid of properties
elsewhere in the state.

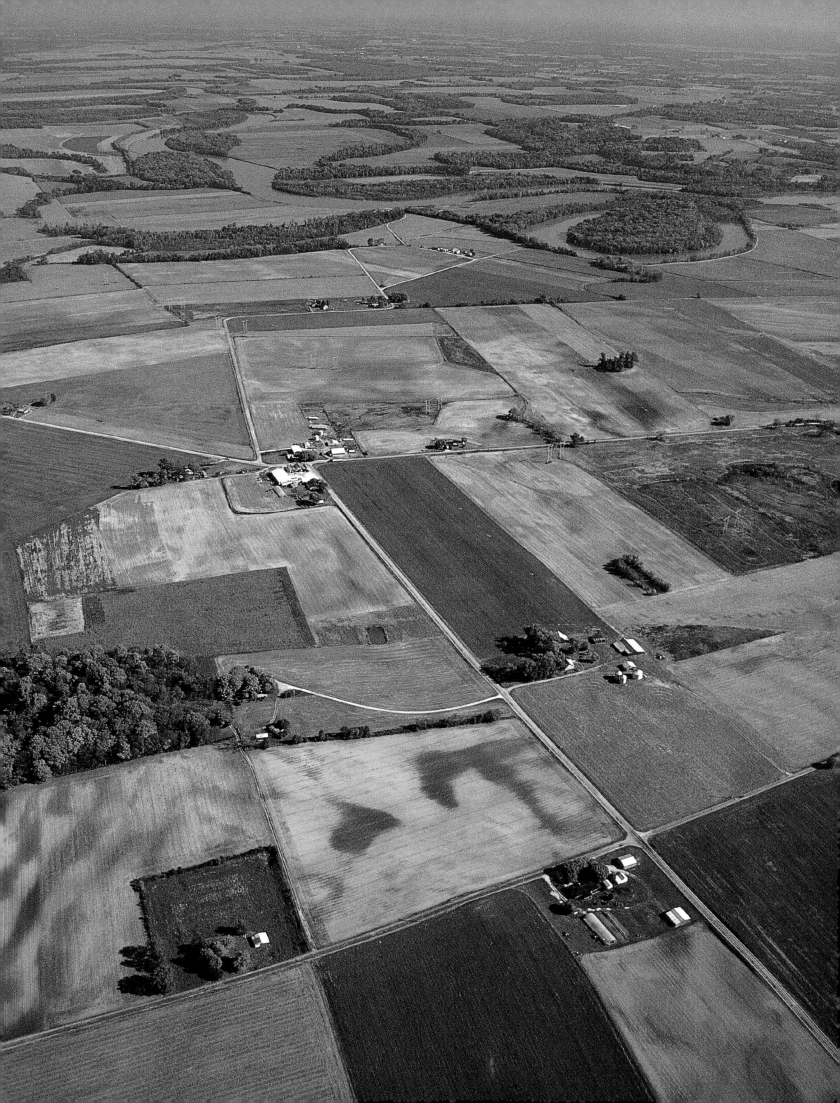

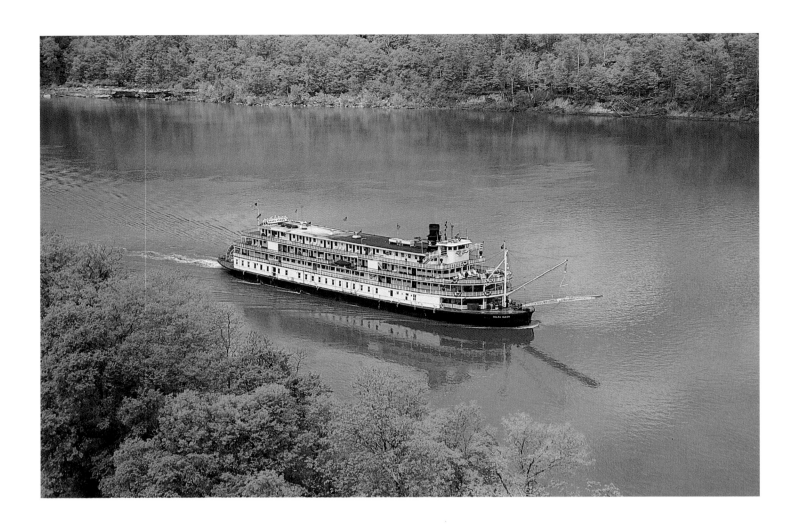

As it steams past southern Spencer County,
the Delta Queen riverboat recalls bygone
days when steam-powered vessels
on the Ohio River were a primary
mode of transportation.

✳

Trees line the sides of a remnant of the
historic Wabash and Erie Canal in Delphi,
Carroll County.

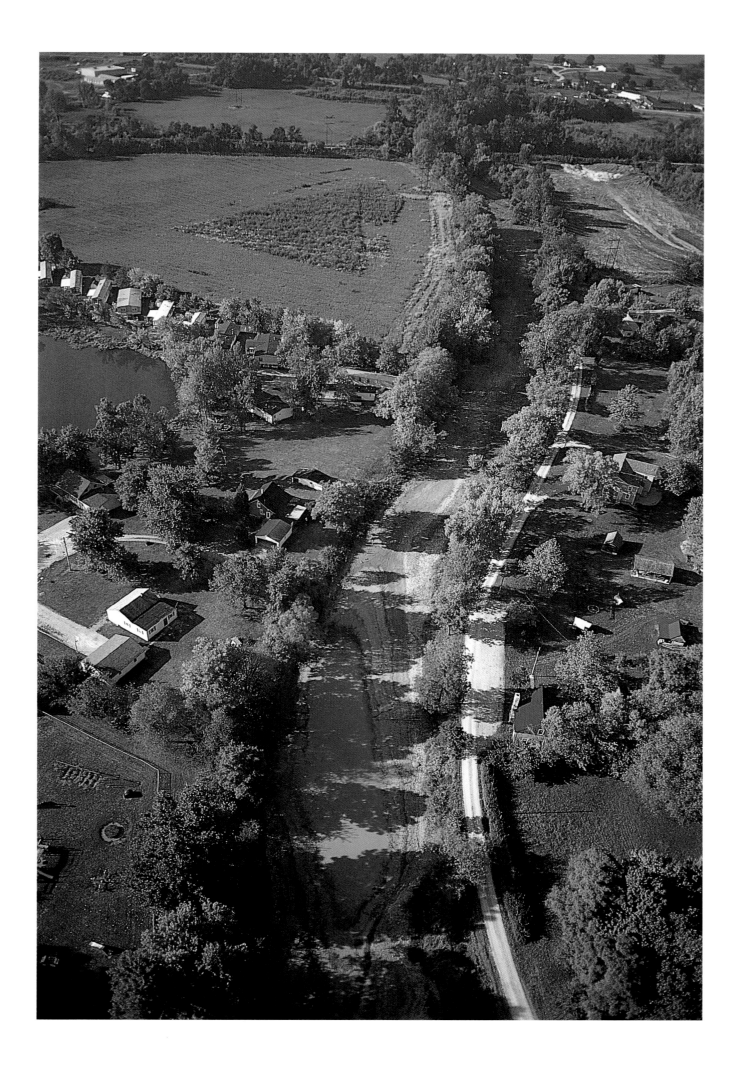

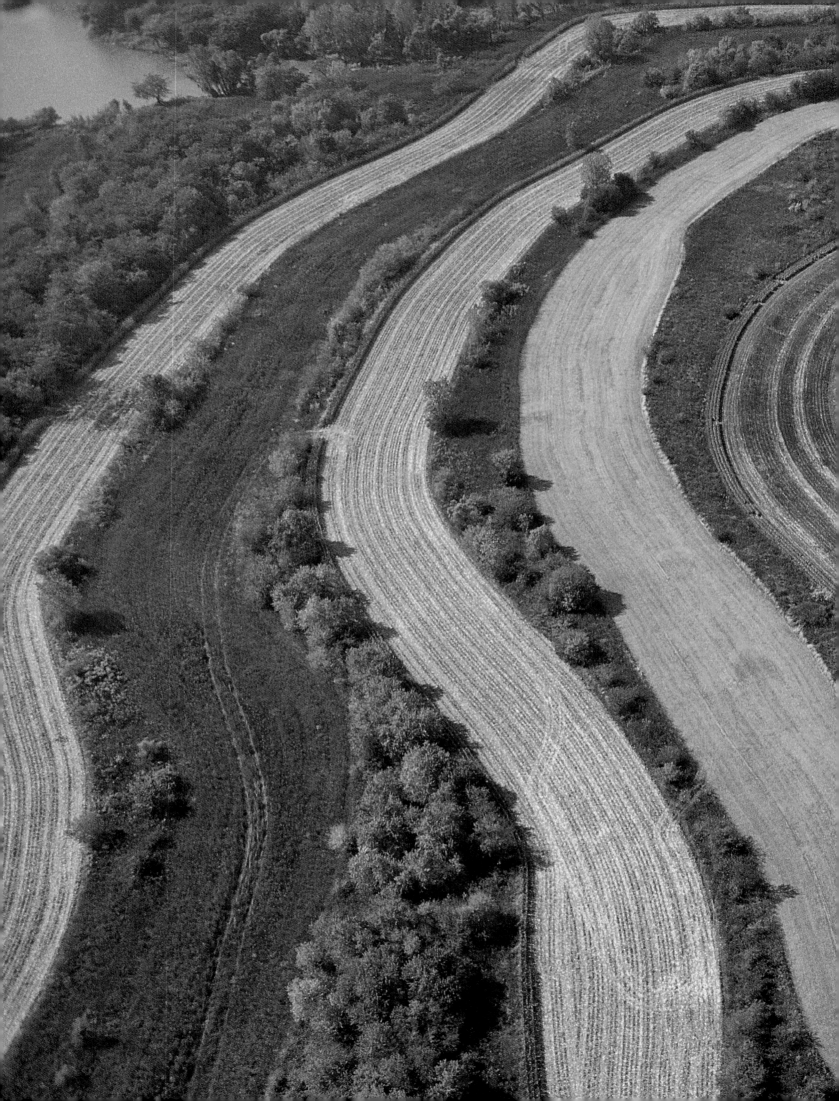

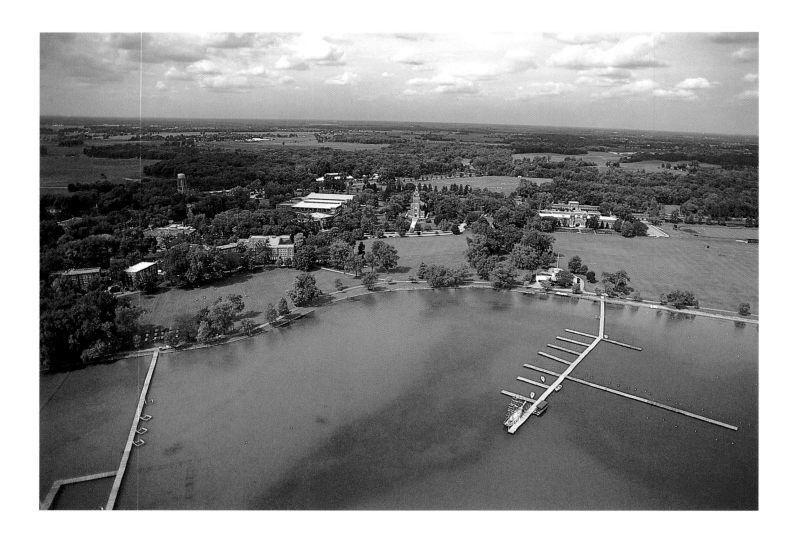

PRECEDING SPREAD: *Wildlife management area adjacent to Mississinewa Reservoir in Wabash County.*

Established in 1894 on the shore of Lake Maxinkuckee in Fulton County, Culver Military Academy is one of the nation's leading preparatory schools.

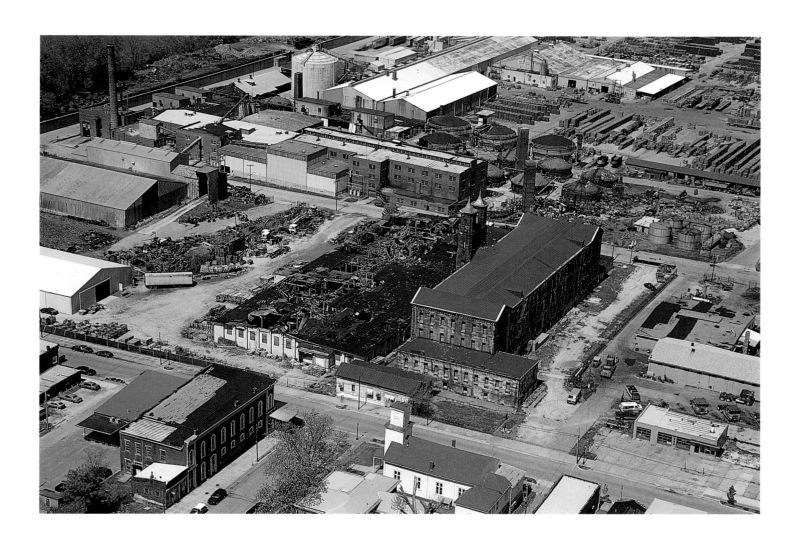

Now a historic landmark commemorating early industry, the Cannelton Cotton Mill in Perry County operated from 1851 to 1954.

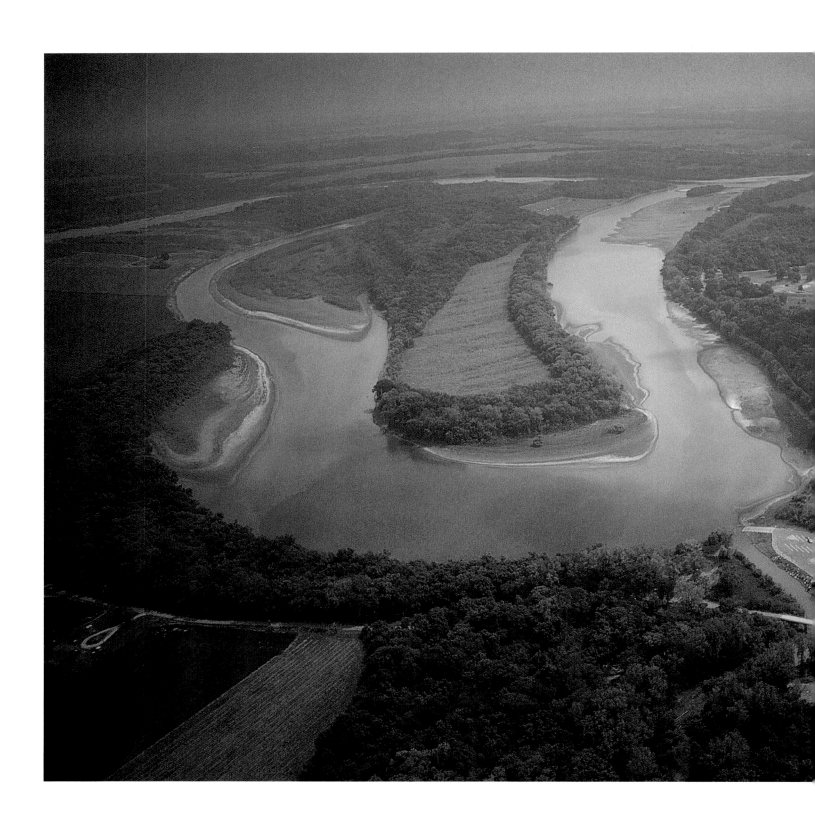

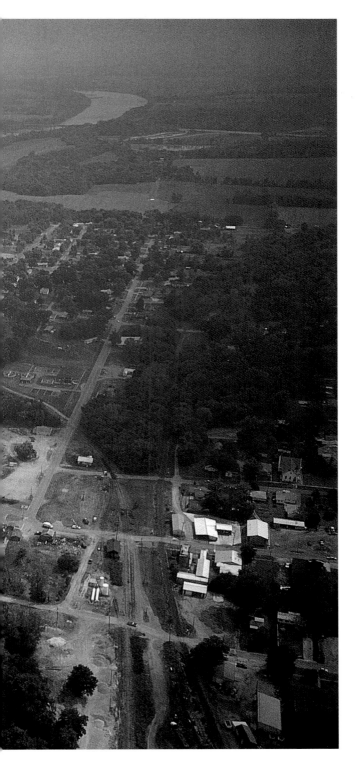

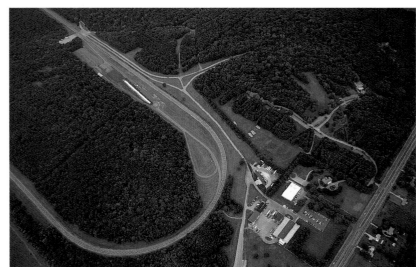

The Wabash River recently cut through
this peninsula in southwestern Gibson
County across from Grayville, Illinois,
forming the oxbow pond in the
foreground. The former point of land is
now an island separated from the
remainder of the state.

❄

The former Studebaker Corporation
Proving Grounds is now the site of Bendix
Woods County Park and Nature Center in
Saint Joseph County.

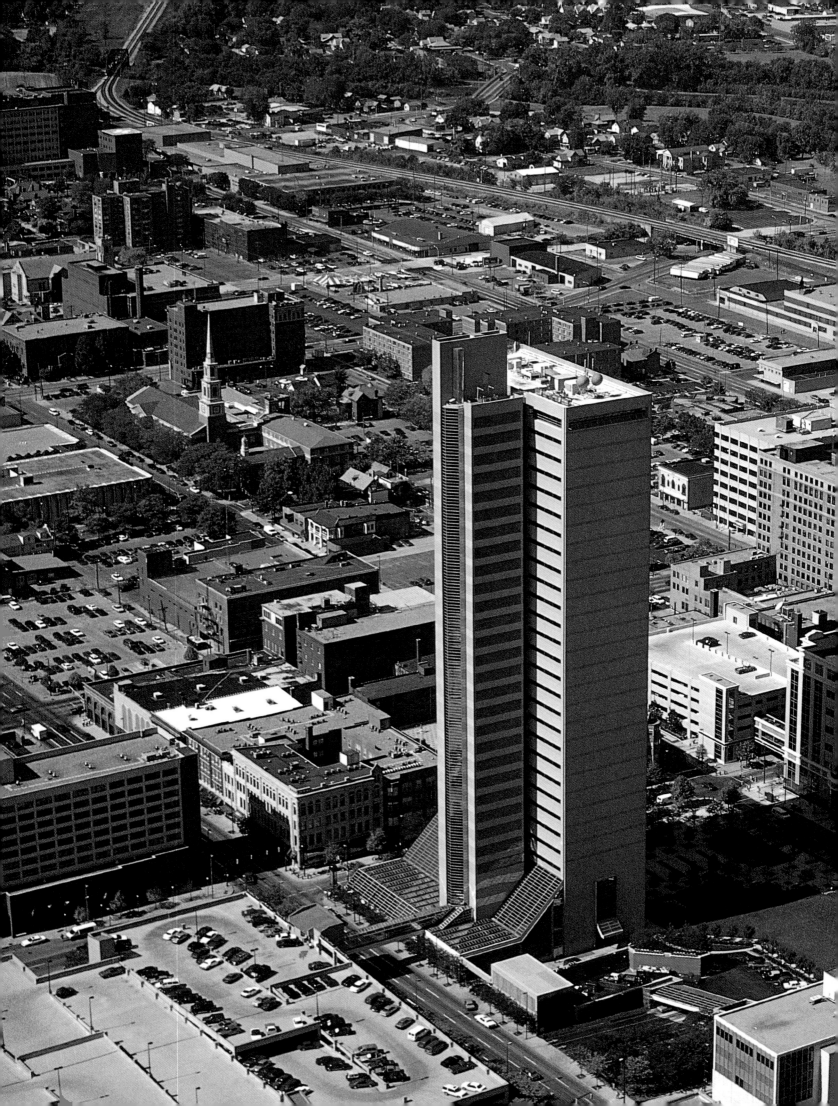

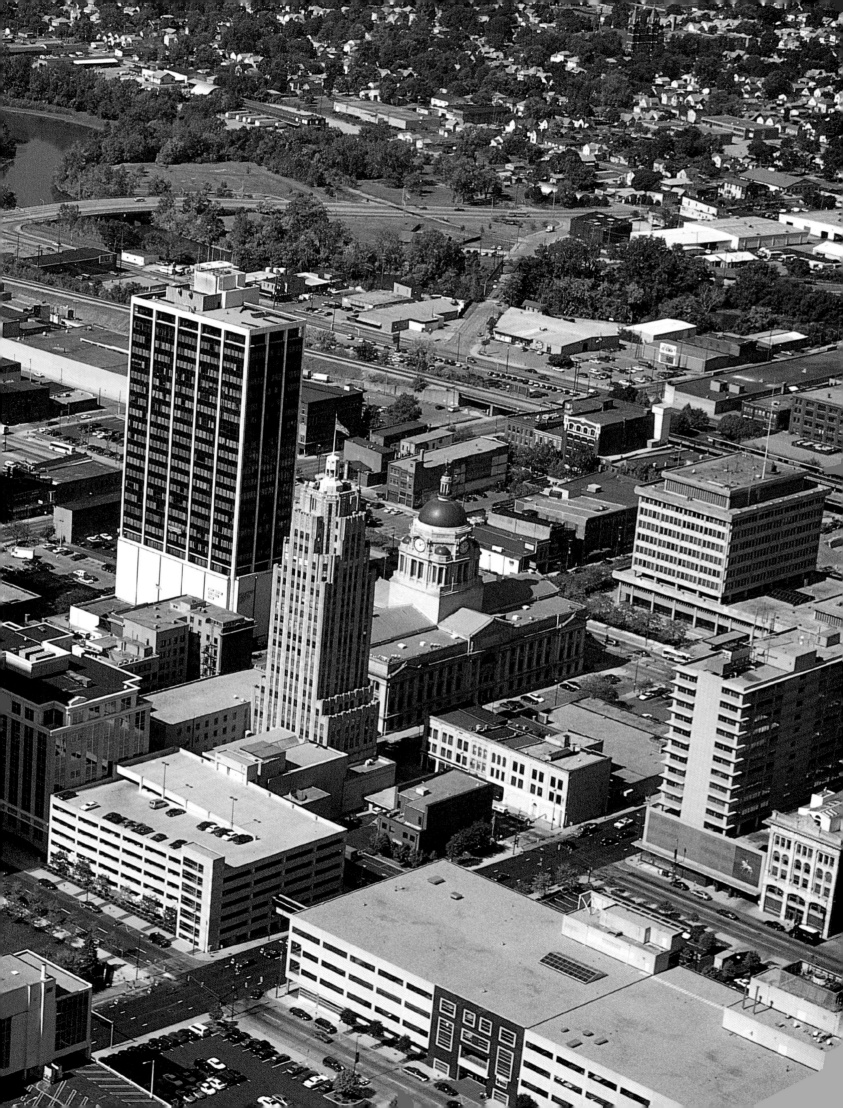

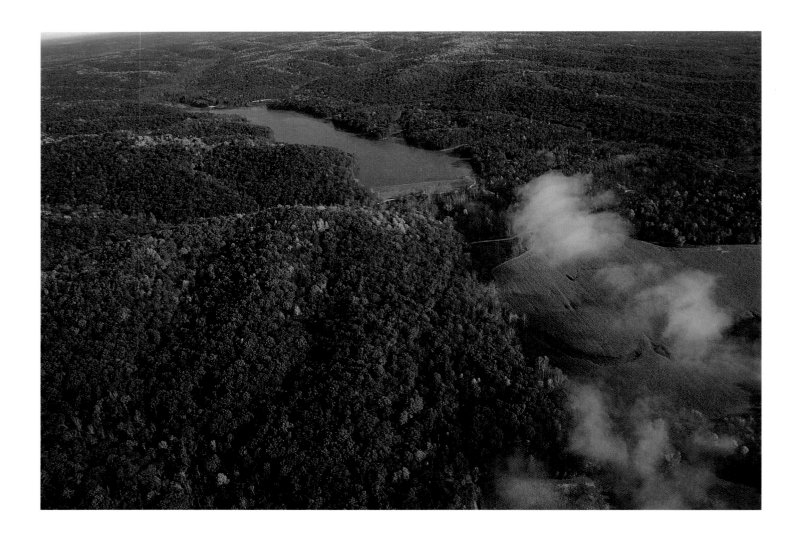

PRECEDING SPREAD: *Originally the site of a Miami Indian village, then of a French fort established in 1722, Fort Wayne is Indiana's second-largest city and the seat of Allen County.*

Yellowwood Lake in Yellowwood State Forest is a popular outdoor destination for many Hoosiers.

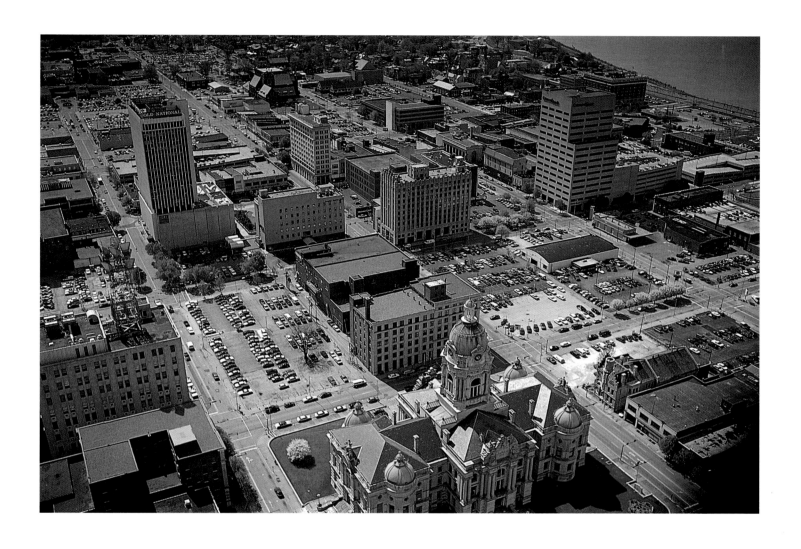

An early industrial and shipping center
on the Ohio River, Evansville in
Vanderburgh County has grown from only
a hundred residents in 1820 to become
Indiana's fourth-largest city.

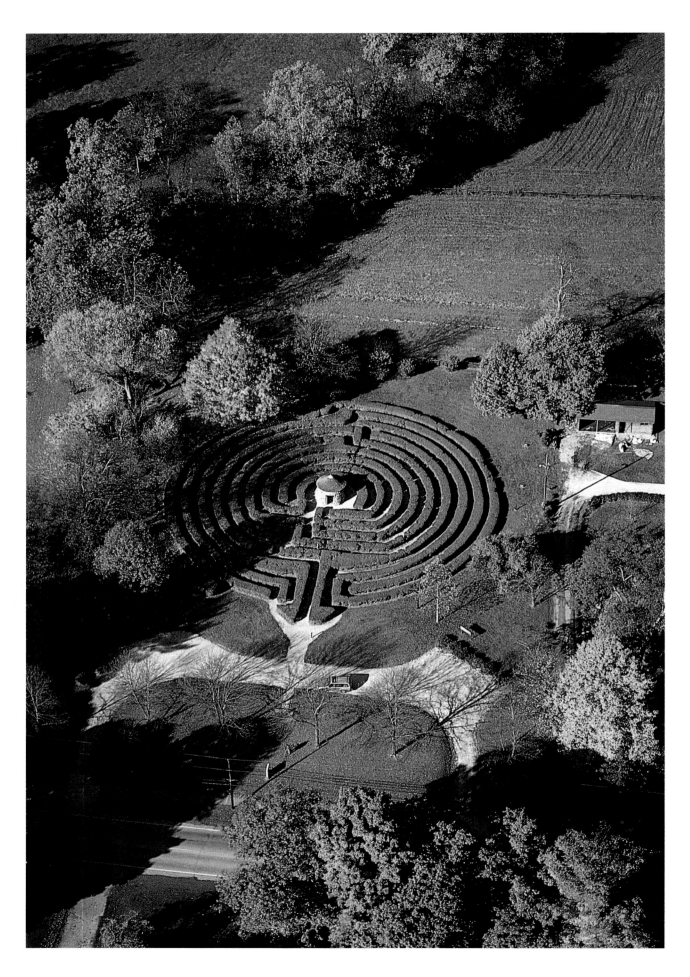

The Labyrinth at New Harmony State Historic Site, Posey County. Built by the Harmonists, an early communal society, the circular maze represents the difficult path to enlightenment.

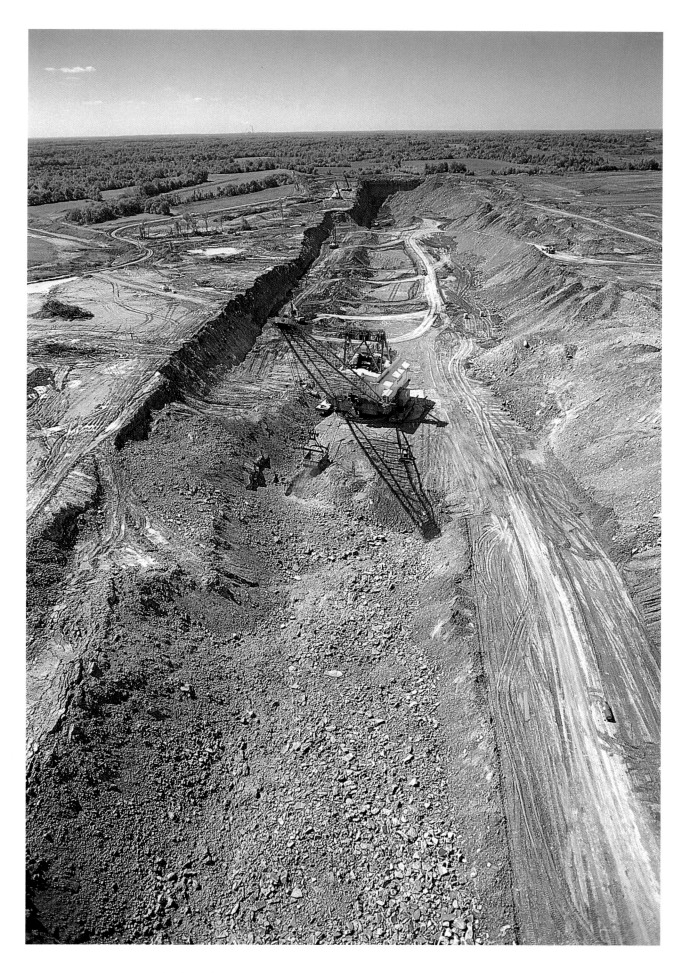

Peabody Coal Company's Hawthorne Mine in southeastern Sullivan County.

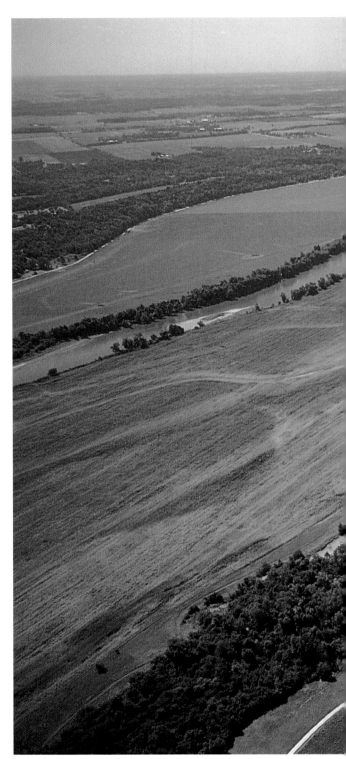

While some settlements located at cross-roads and railroad junctions became thriving cities, others, such as Redkey in Jay County, remained small towns.

✳

The site of the Indian settlement of Prophetstown from 1808 to 1811, this broad terrace bordering the Wabash River witnessed the Battle of Tippecanoe on the morning of November 7, 1811; the battle played a decisive role in the defeat of the Indian confederacy pitted against early settlers of the state. The now peaceful fields outside Battle Ground in Tippecanoe County are the location for the proposed new Prophetstown State Park.

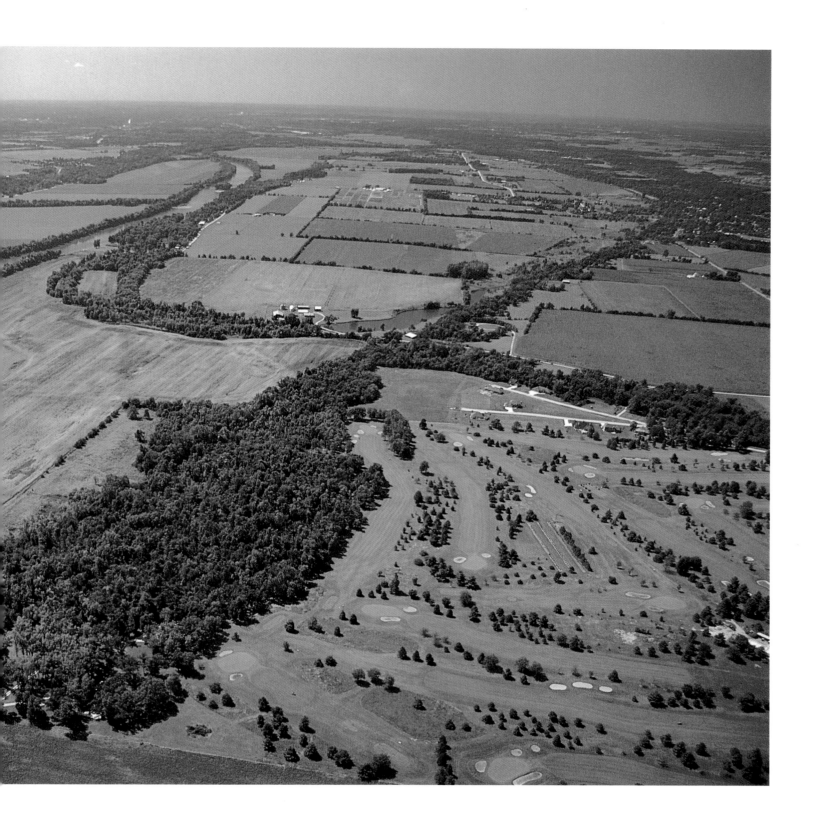

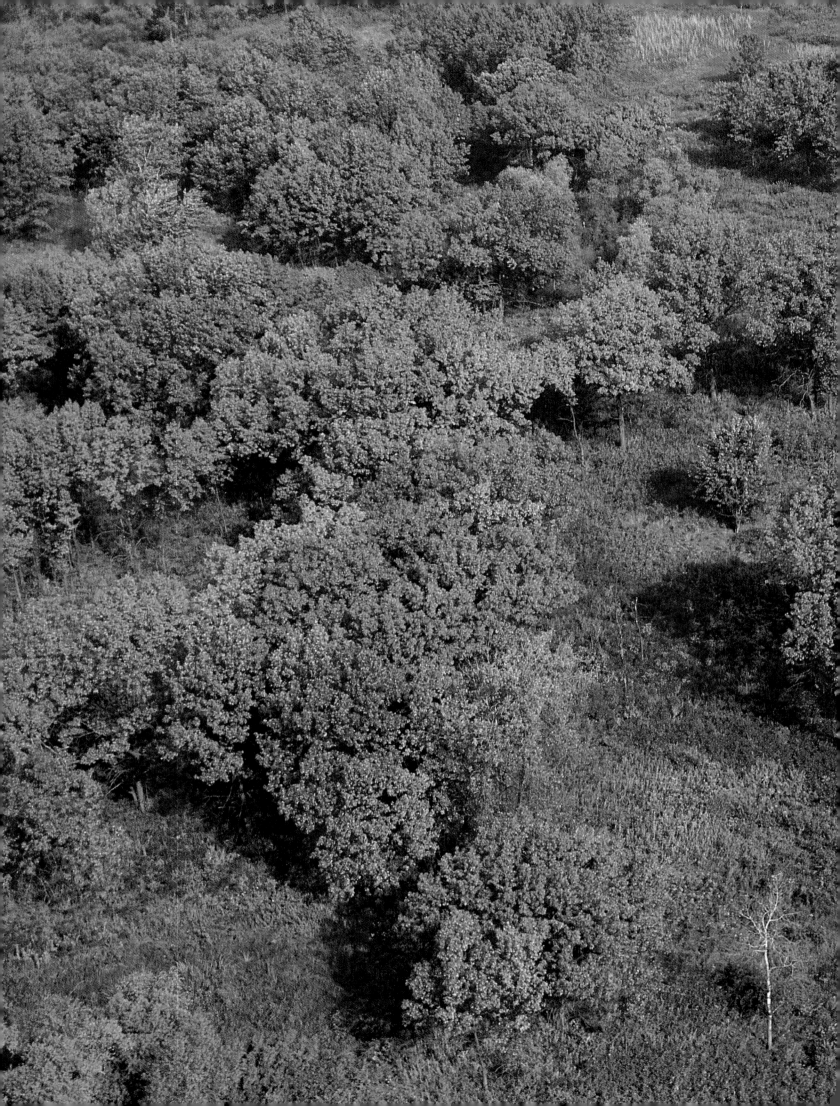

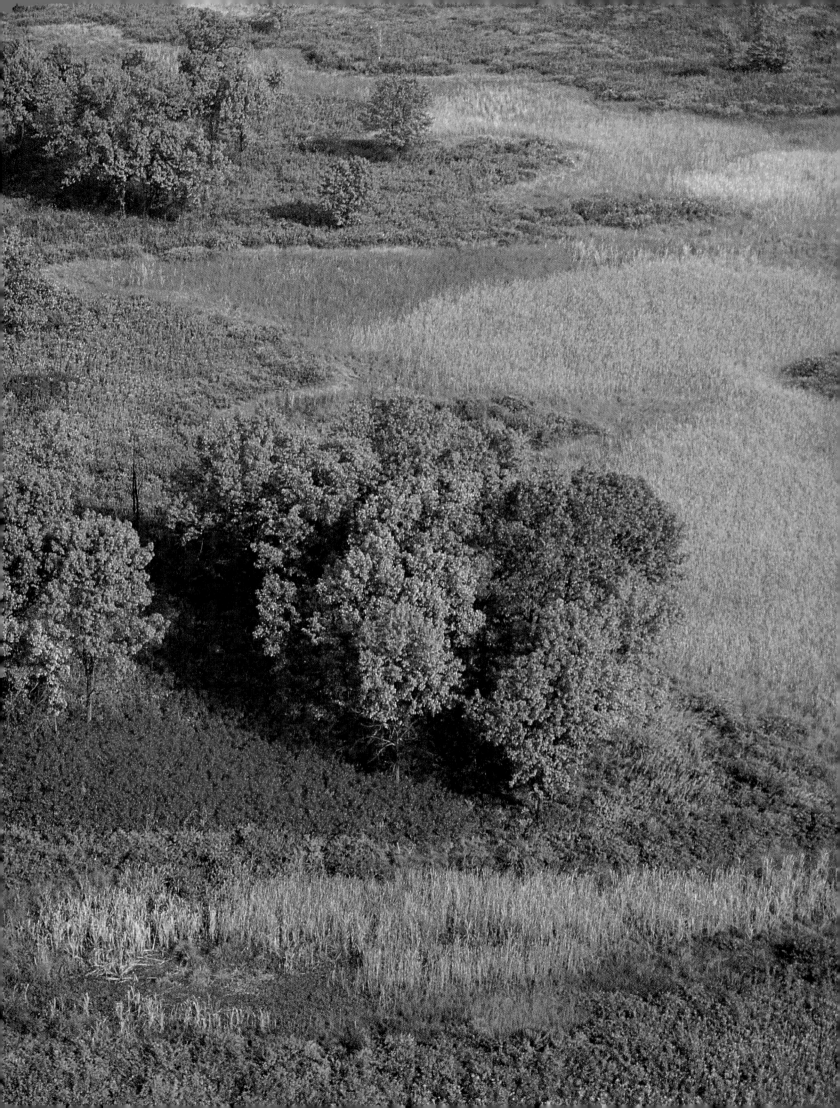

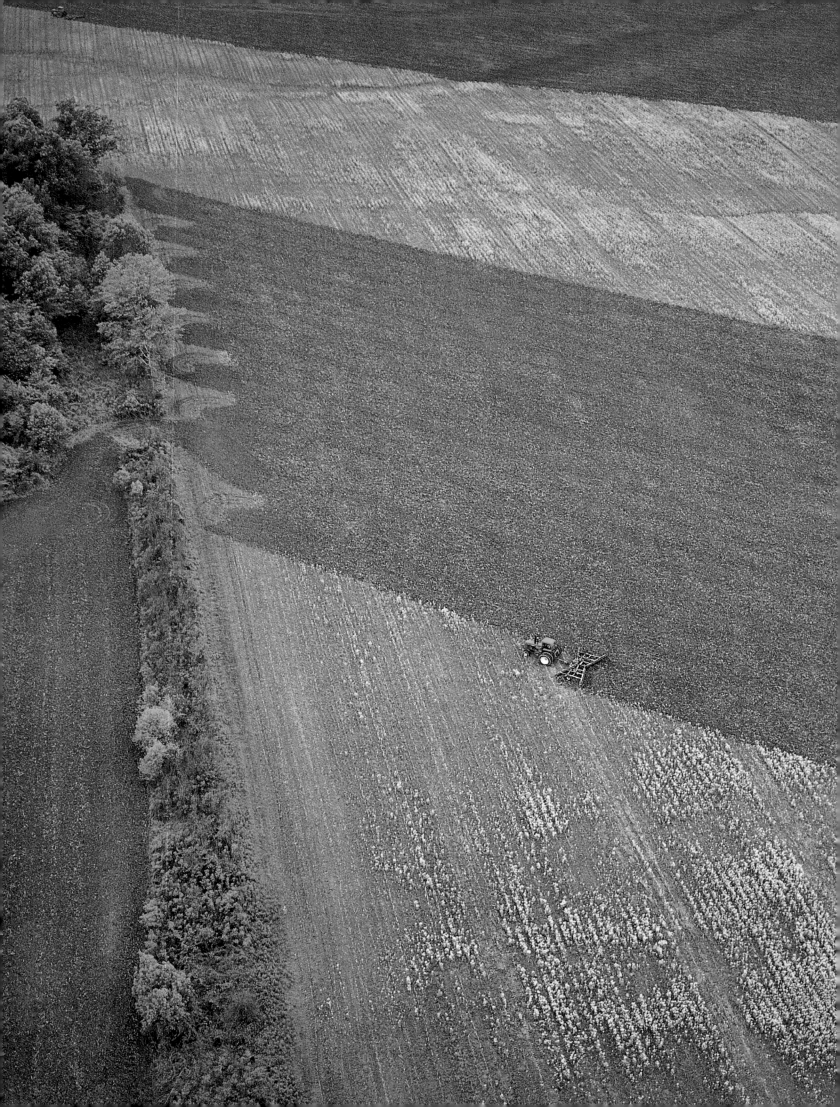

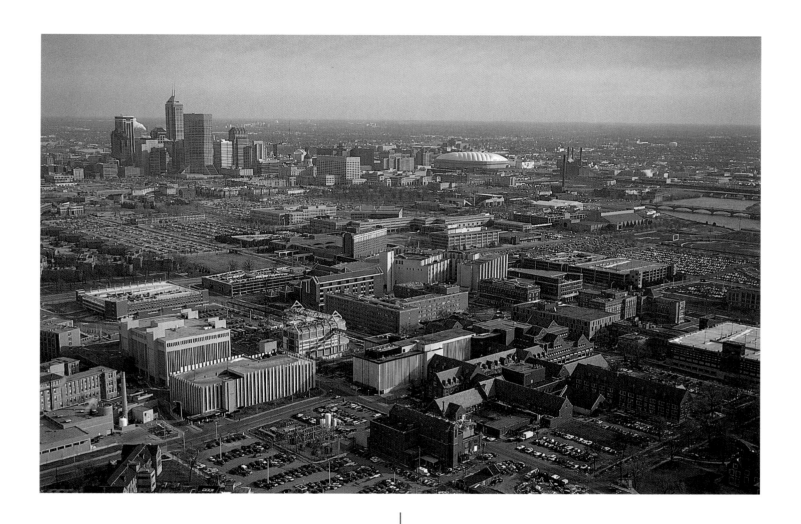

Springtime tilling in a field of butterweed
(Senecio glabellus), *Gibson County.*

✳

Indiana University/Purdue University
at Indianapolis, with downtown
Indianapolis in the background.

PRECEDING SPREAD: *Annual burning helps*
preserve the natural grasslands and
widely spaced black oaks at Hoosier
Prairie Nature Preserve in Lake County,
the largest remaining parcel of native
prairie and oak savanna in the state.

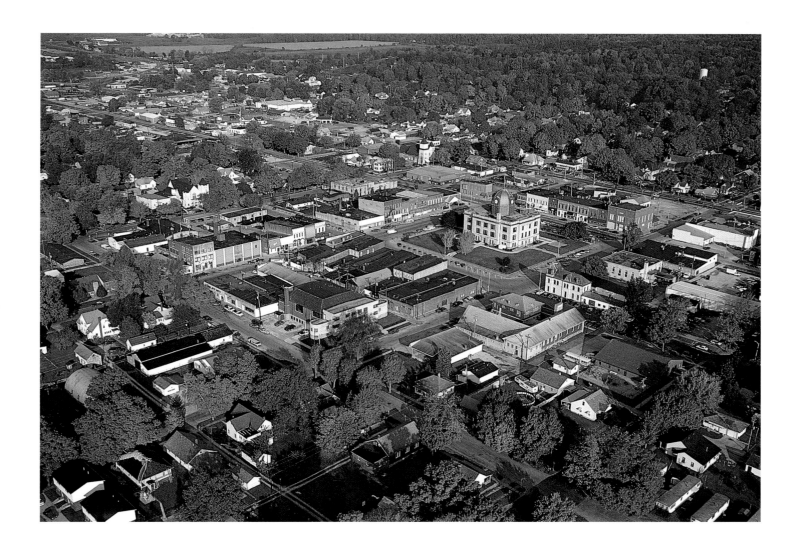

Rugged terrain of Browning Hill, just east of Monroe Reservoir in the Hoosier National Forest, Brown County.

✴

The Owen County Courthouse, built in 1911, graces downtown Spencer, established as the county seat in 1820.

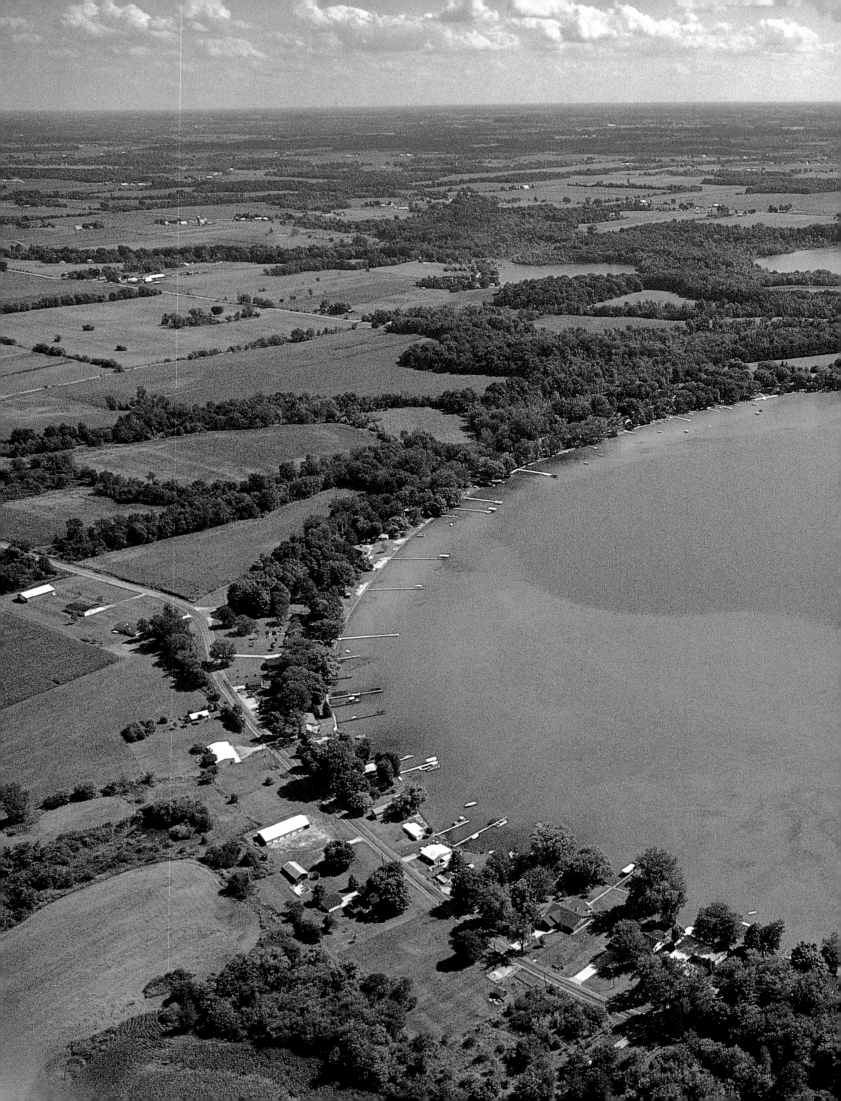

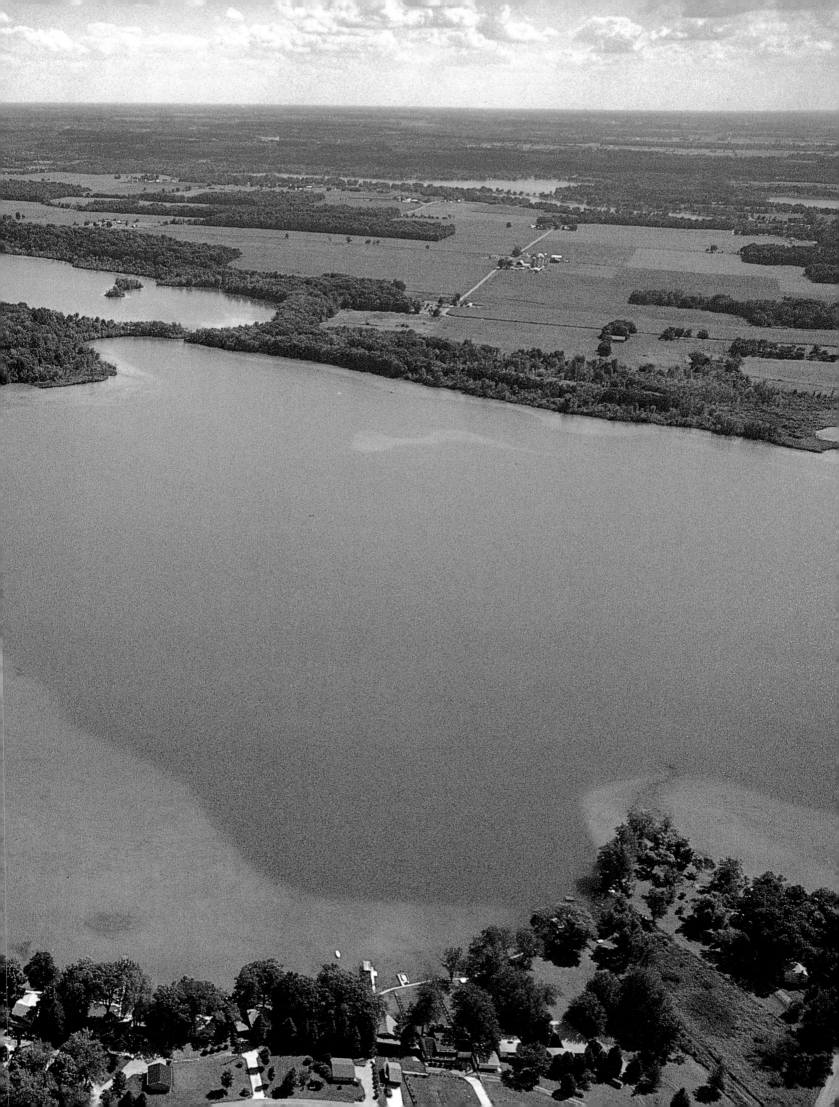

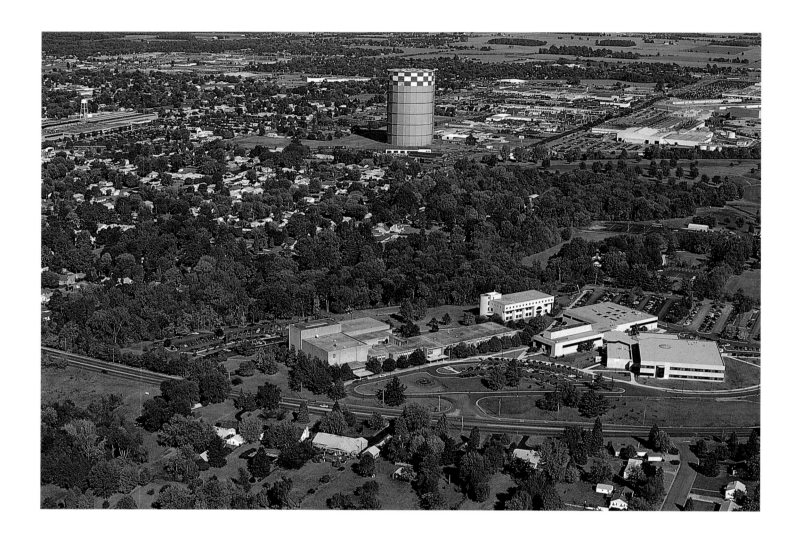

PRECEDING SPREAD: *Because of the relatively superior quality of the water, the shallow marl flats of Oliver Lake in Lagrange County can easily be seen here. Beyond lies Olin Lake, which at just over 100 acres is the largest remaining lake in the state with an undeveloped shoreline; it is now protected as a state nature preserve.*

This gigantic natural gas tower dominates the skyline of Kokomo, the seat of Howard County, and symbolizes the great importance of natural gas in the rapid industrialization of this region of Indiana near the turn of the century. The Kokomo campus of Indiana University lies in the foreground.

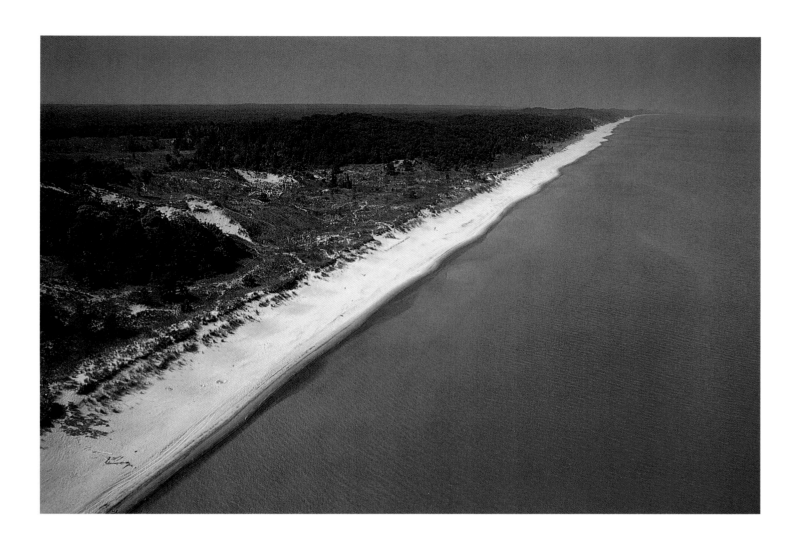

The great influence of Lake Michigan on Dunes State Park in Porter County can be seen in the formation of blowouts where forest cover is removed from the row of dunes facing the Lake Michigan shoreline.

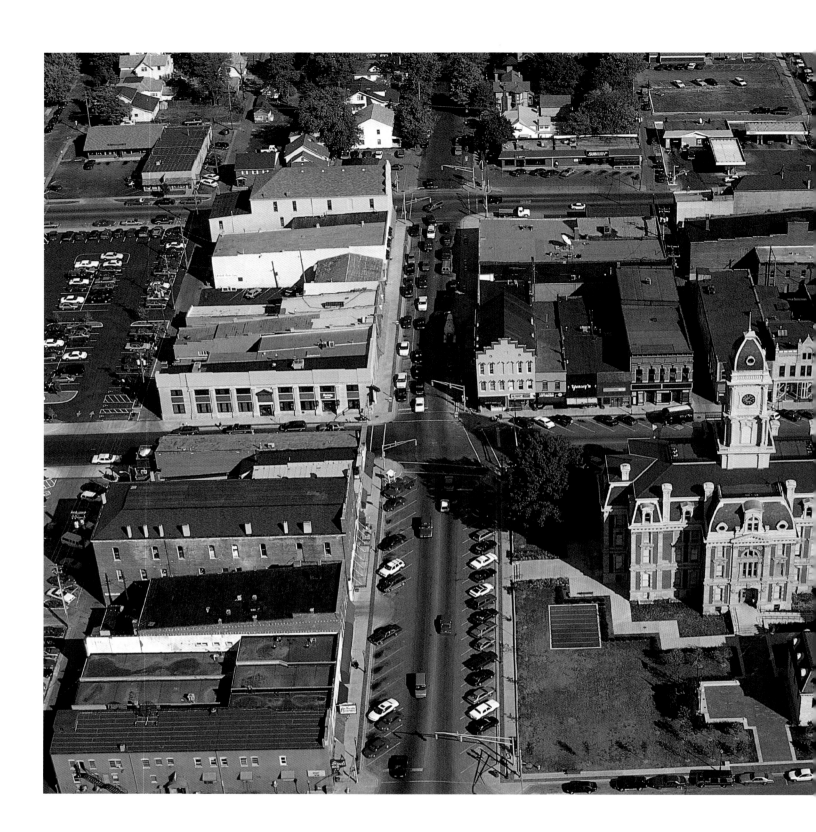

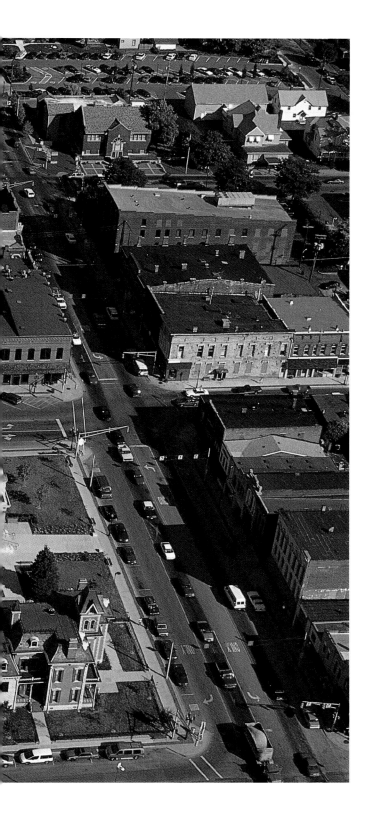

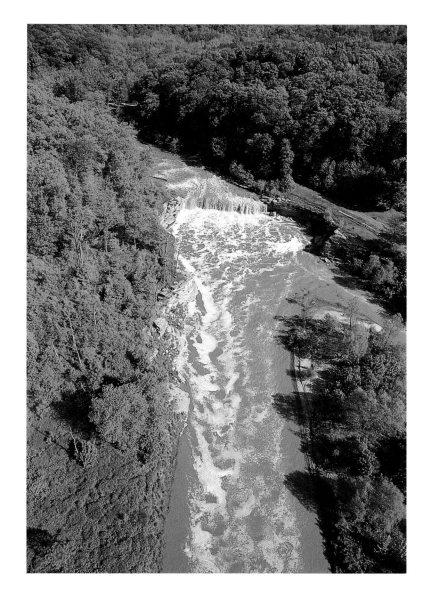

Hamilton County Courthouse, built in 1879, and former county jail and sheriff's residence, downtown Noblesville.

✳

Lower Cataract Falls roars after a recent spring rainstorm in northern Owen County.

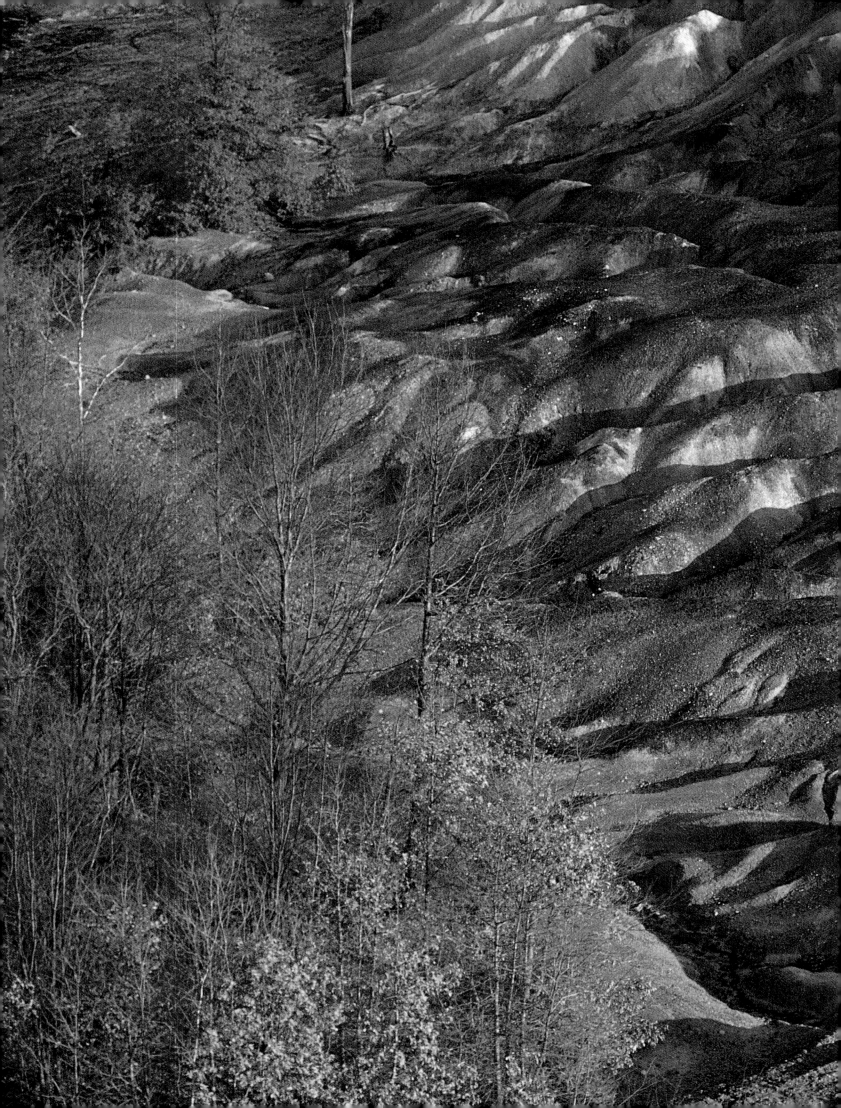

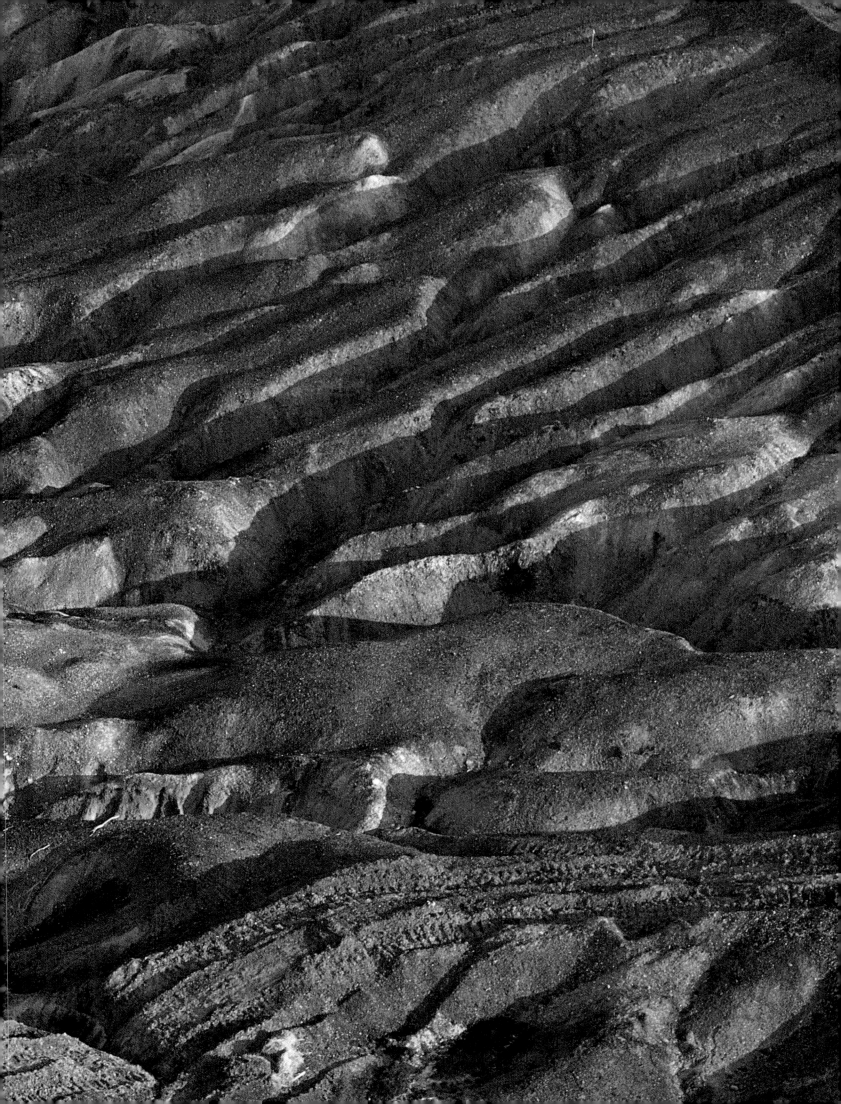

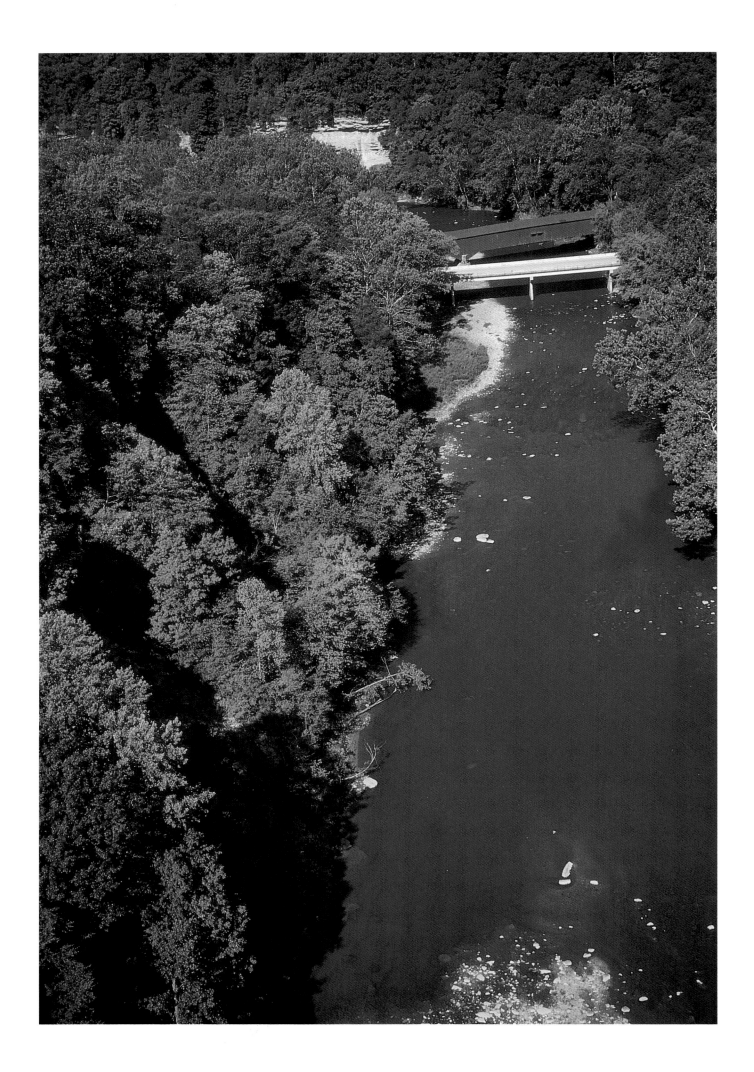

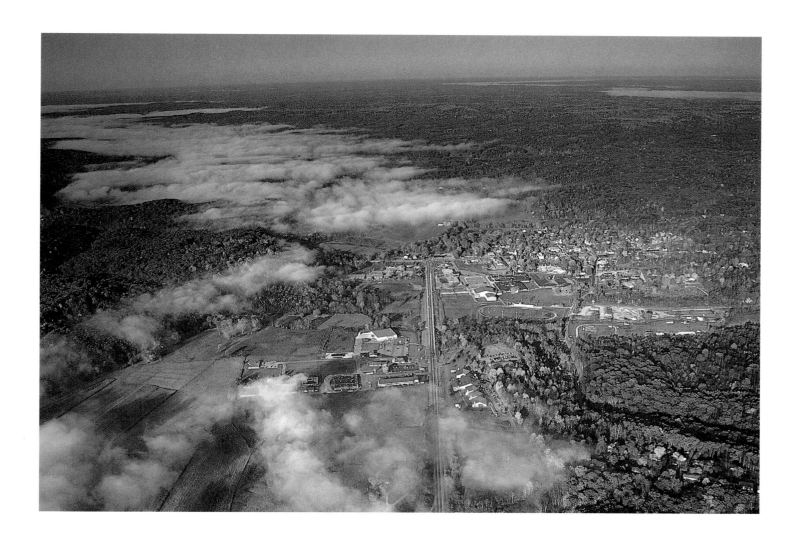

Deer Mill Covered Bridge and its modern replacement cross Sugar Creek adjacent to Shades State Park in Montgomery County.

Early morning fog lifts from Nashville, Brown County.

PRECEDING SPREAD: *Spoil piles, prior to reclamation, at the Green Valley surface coal mine in Vigo County.*

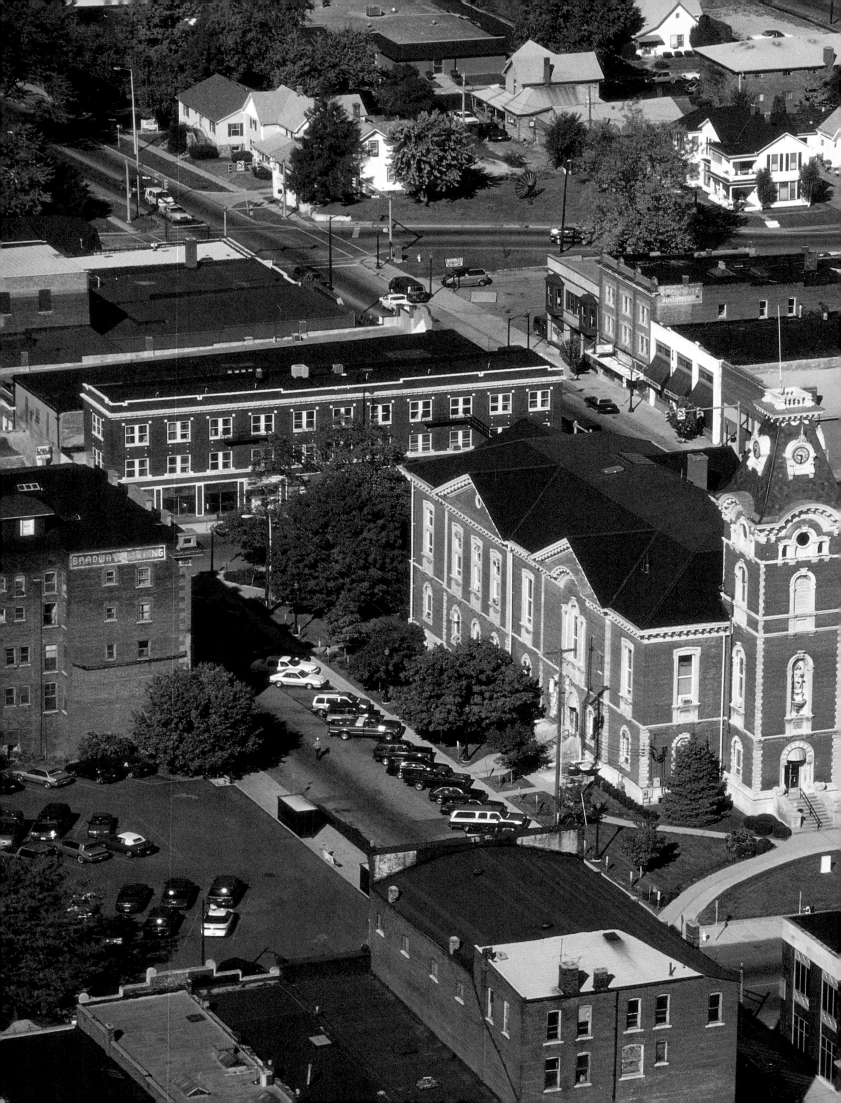

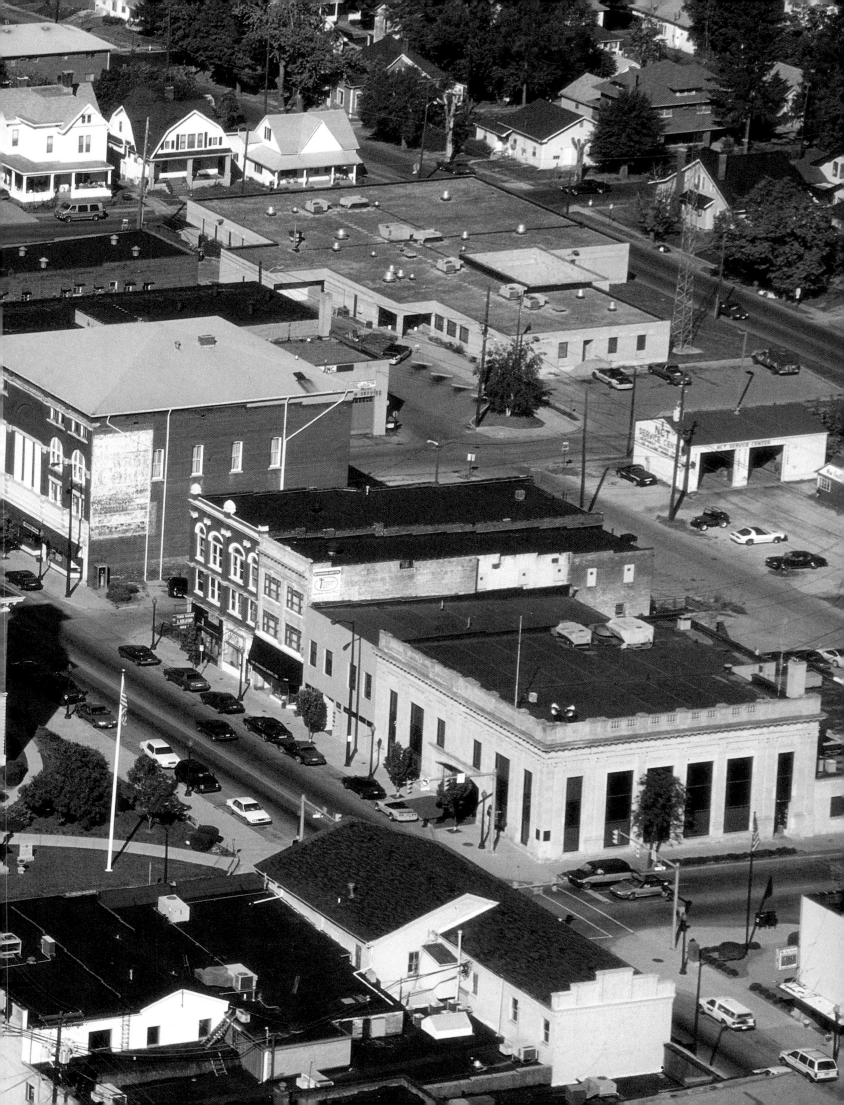

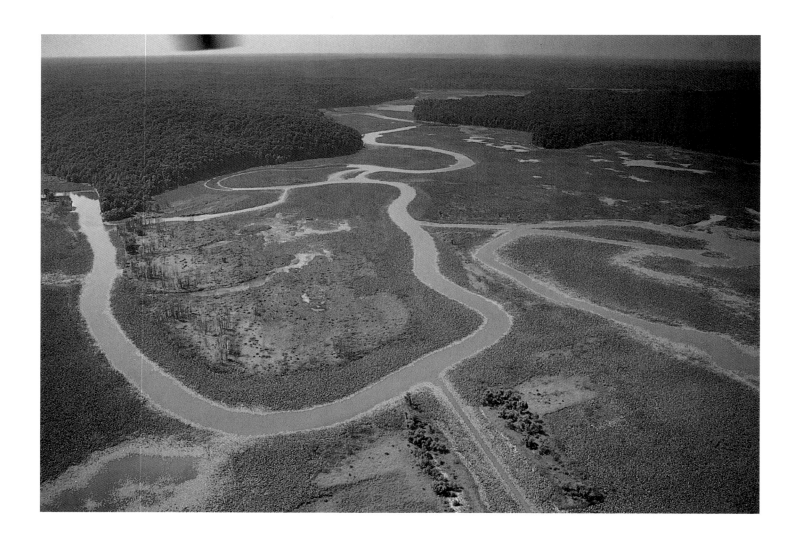

PRECEDING SPREAD: *The Henry County Courthouse in downtown New Castle, built in 1869.*

The old channel of Salt Creek can still be seen meandering through wetlands in the upper reaches of Monroe Reservoir, with the Charles Deam Wilderness Area (Hoosier National Forest) in the background; Brown County.

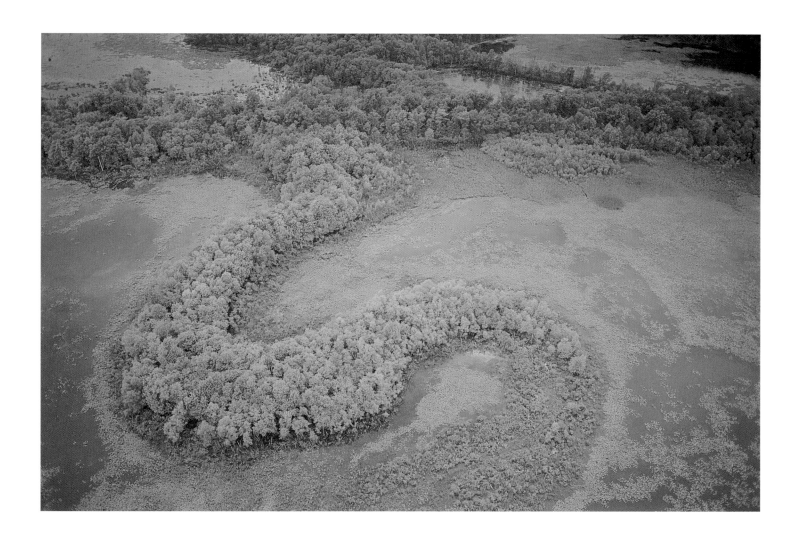

Trees now line an old river meander at Snakey Point along the South Fork Patoka River near Oakland City, Gibson County.

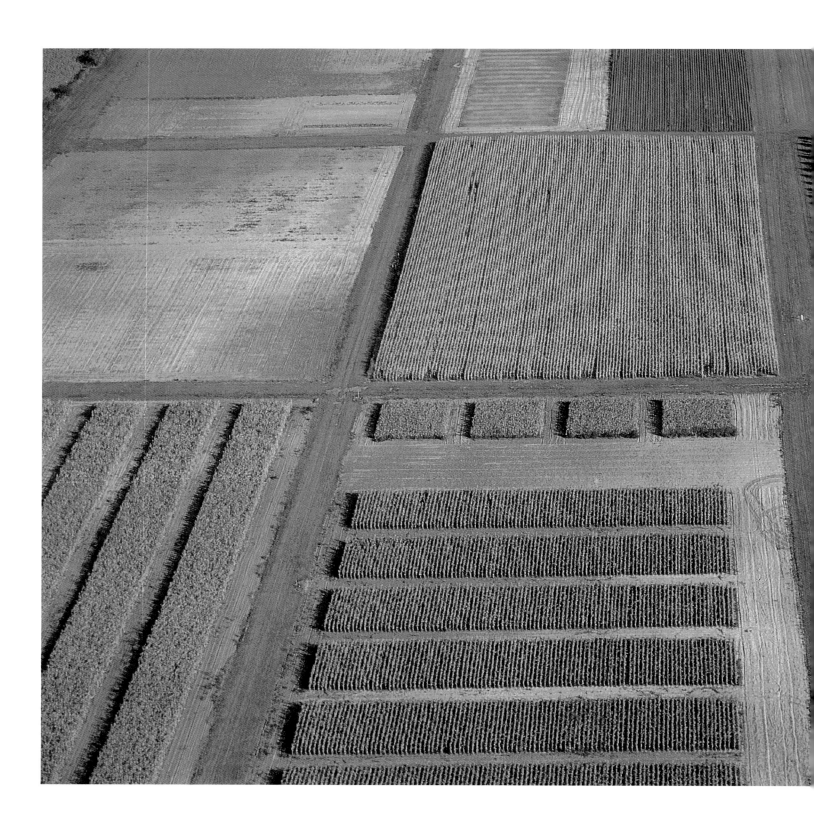

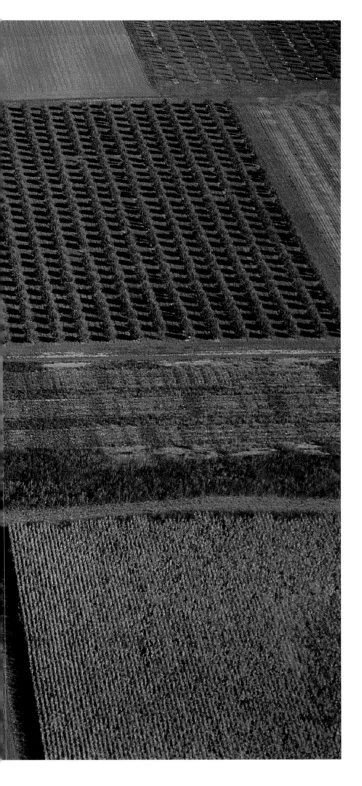

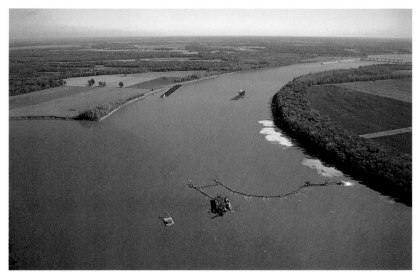

Eli Lilly agricultural research fields, Hancock County.

The confluence of the Ohio and Wabash Rivers in Posey County marks the southwesternmost point in Indiana. Dredging (seen here on the Kentucky side of the Ohio River) is often necessary to maintain an open shipping channel.

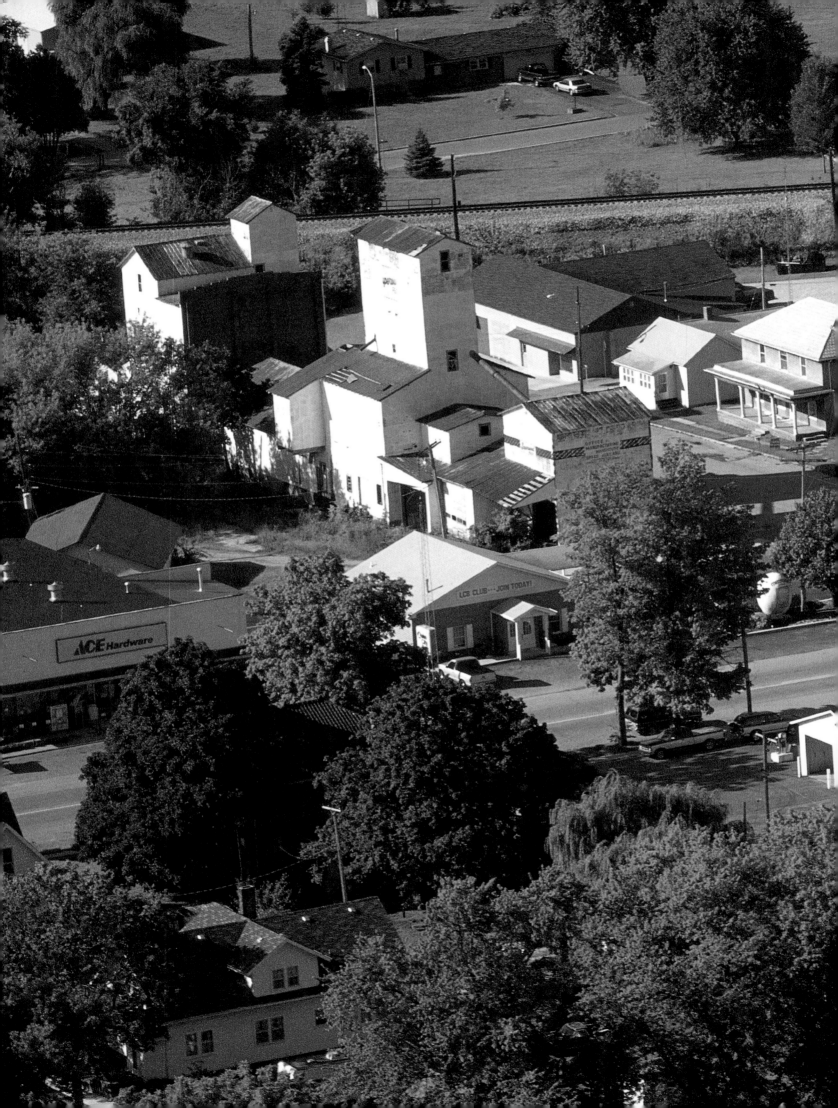

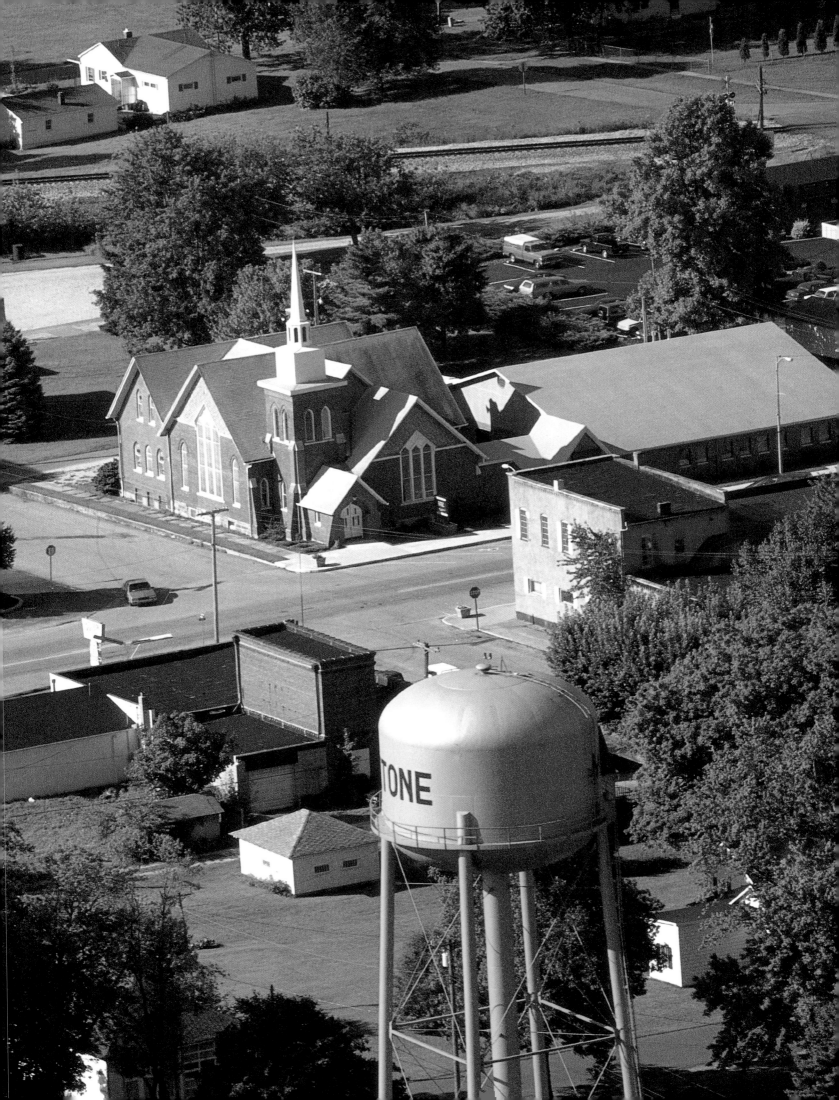

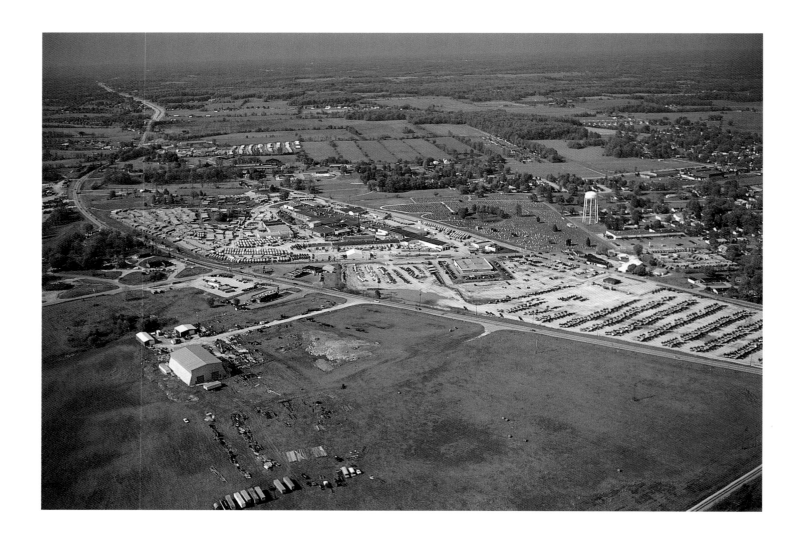

PRECEDING SPREAD: *A 3,000-pound concrete egg in the middle of Mentone in south-western Kosciusko County proclaims the town to be the "Egg Basket of the Midwest."*

The Carpenter Body Works in Mitchell, Lawrence County, is one of the nation's largest manufacturers of school buses.

Powers Church, built in 1876, last held regular services in the 1920s and is now a restored historic landmark in eastern Steuben County.

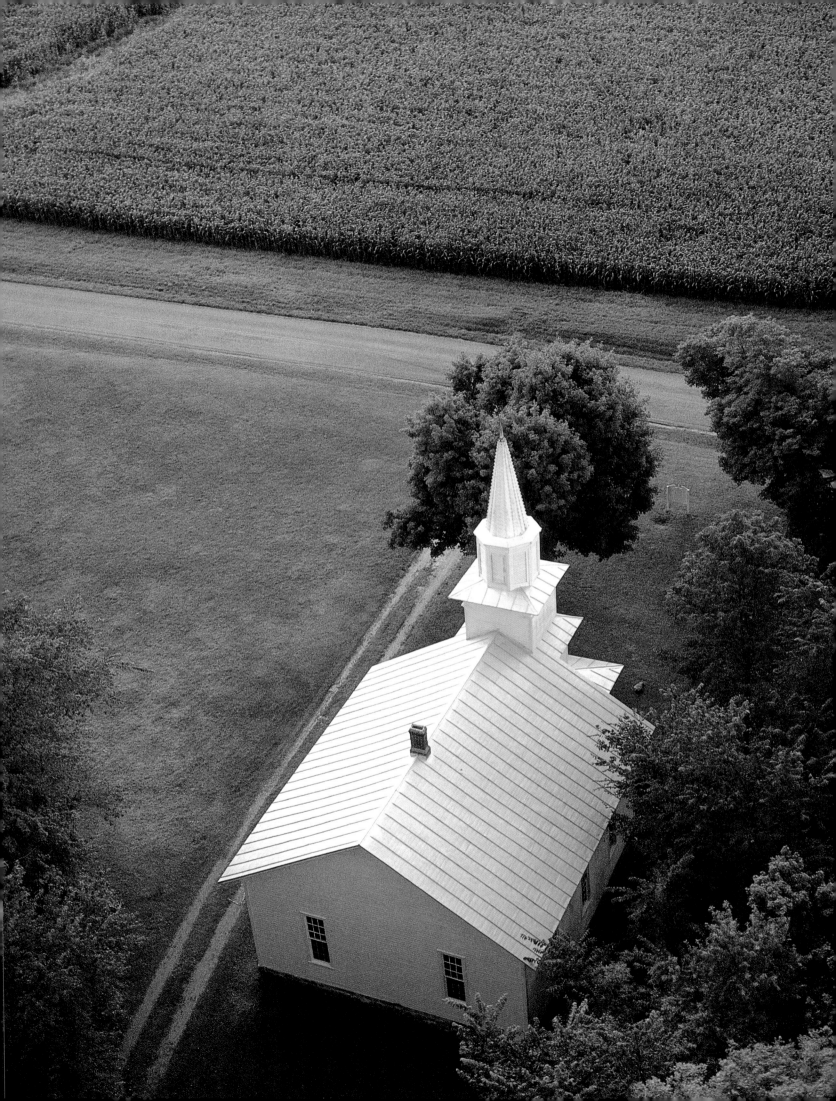

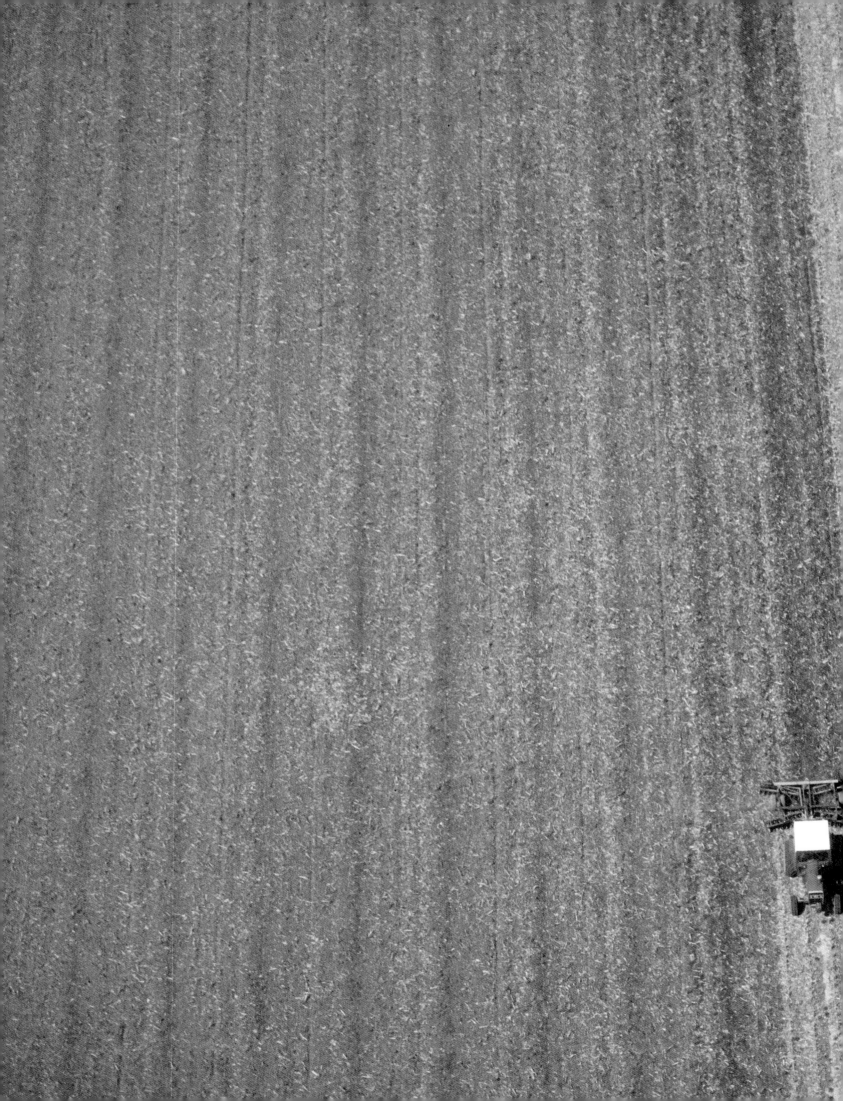

PRECEDING SPREAD: *Glacial ice sheets repeatedly leveled the north-central till plain of the state, now Indiana's agricultural heartland. Spring plowing in Tipton County.*

This statue of a Native American chief fails to stop much traffic at this intersection in Montpelier, Blackford County.

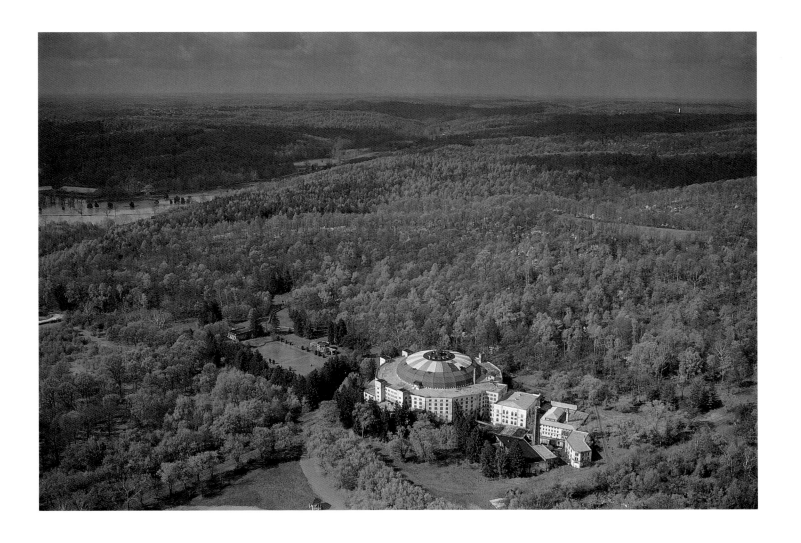

The former West Baden Springs Hotel in Orange County was frequented by such guests as Al Capone in its heyday. Featuring the world's third-largest unsupported dome, this deteriorating structure is now one of Indiana's most threatened landmarks.

Great blue heron (Ardea herodias) *nests fill a sycamore tree in a rookery along Prairie Creek in southwestern Vigo County.*

✳

Forest land seasonally flooded for wildlife habitat, otherwise known as a "green tree reservoir," at Muscatatuck National Wildlife Refuge, Jackson County.

FOLLOWING SPREAD: *A deeply incised canyon marks where Bear Creek winds its way through Portland Arch Nature Preserve on its way to its confluence with the Wabash River just outside the town of Fountain in Fountain County.*

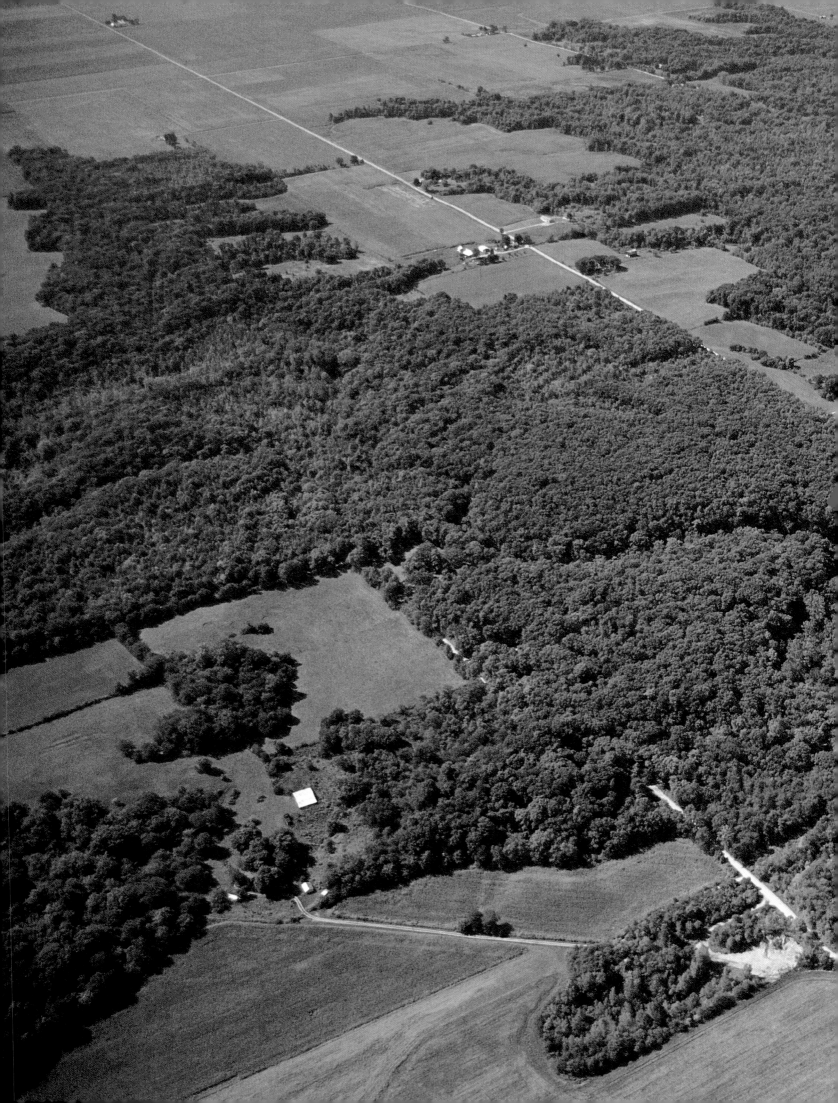

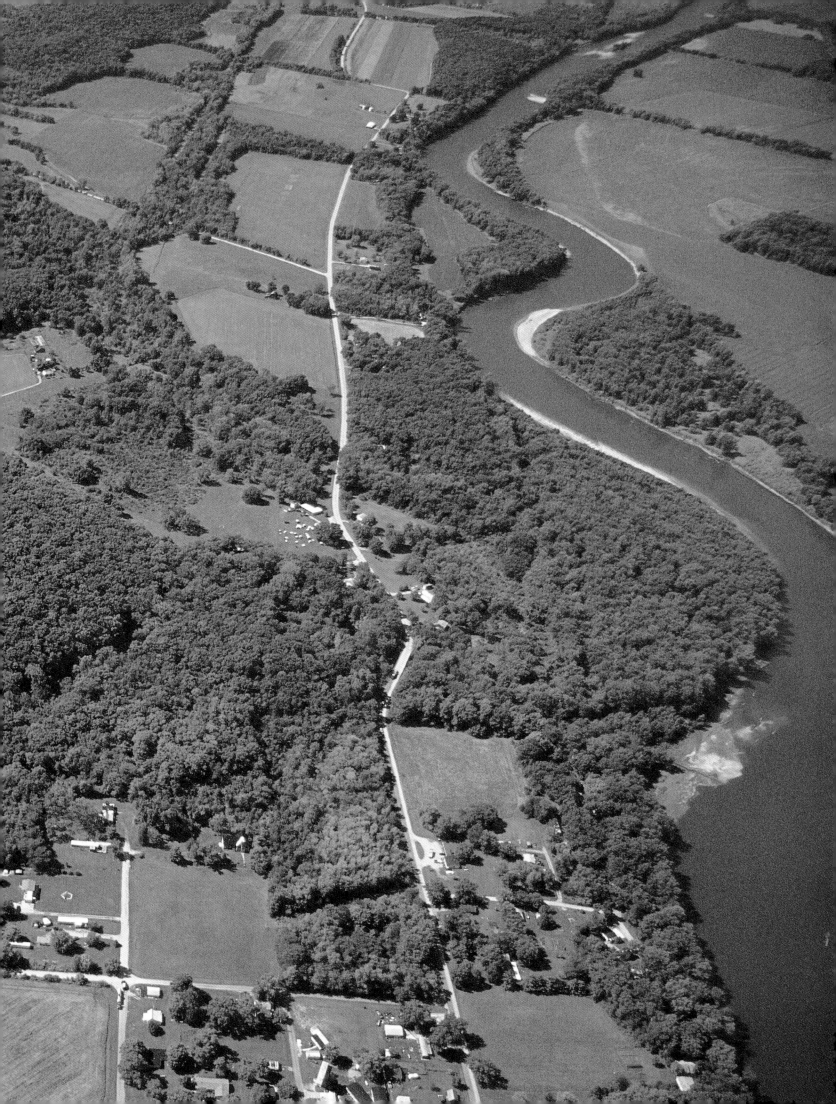

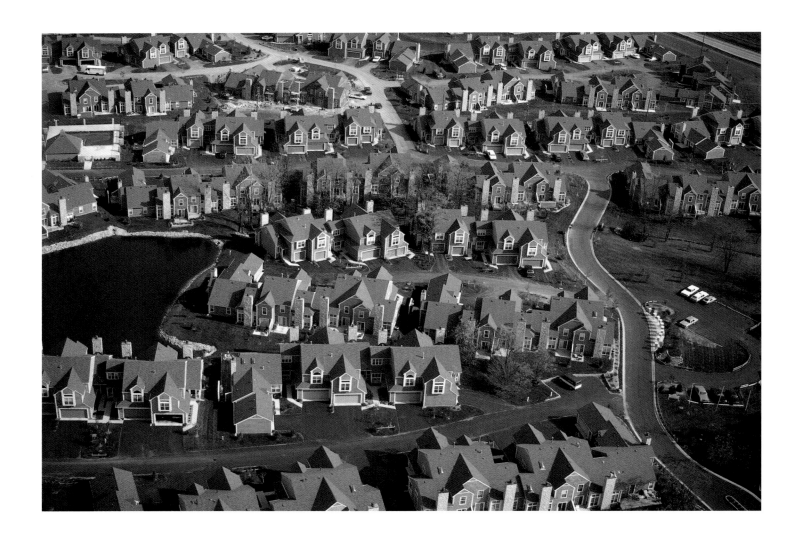

Indiana's landscape is constantly changing, ever dynamic. Farm fields, meadows, and woodlots give way to apartments on the west side of Indianapolis. Whether change is good or bad depends on the eye of the beholder . . . and where one lives.

A mosaic of vegetation patterns formed by a wetland forest opening in Bloomfield Barrens Nature Preserve located along Little Pigeon Creek, Spencer County.

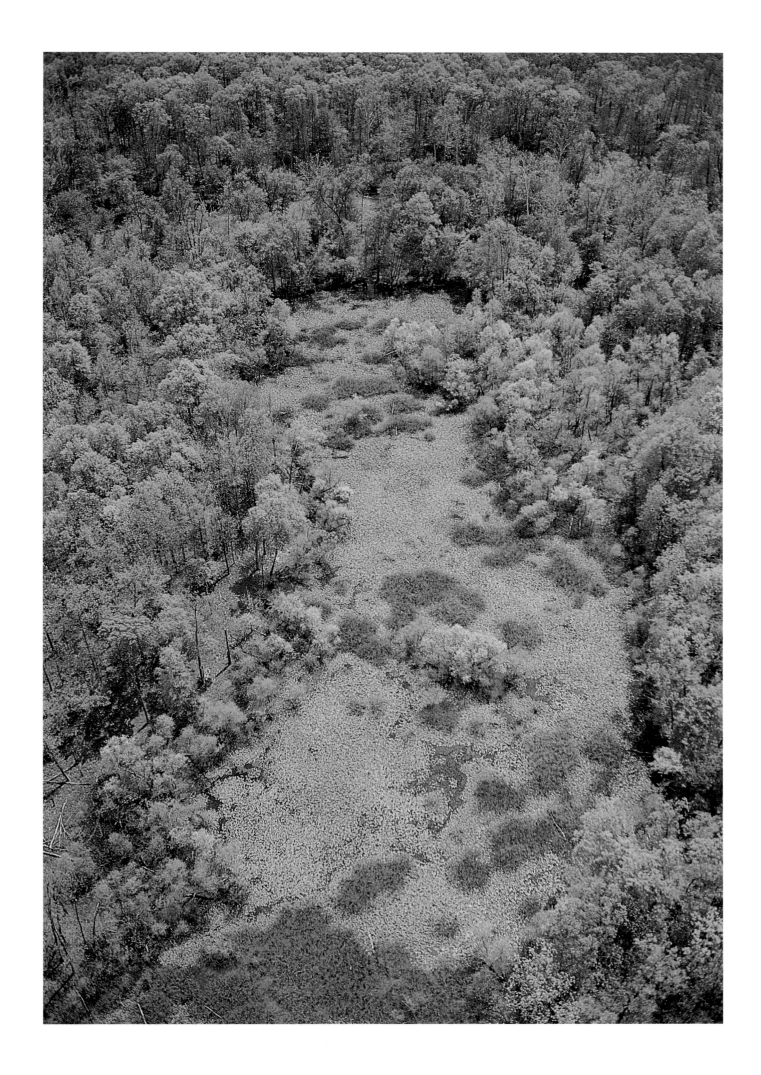

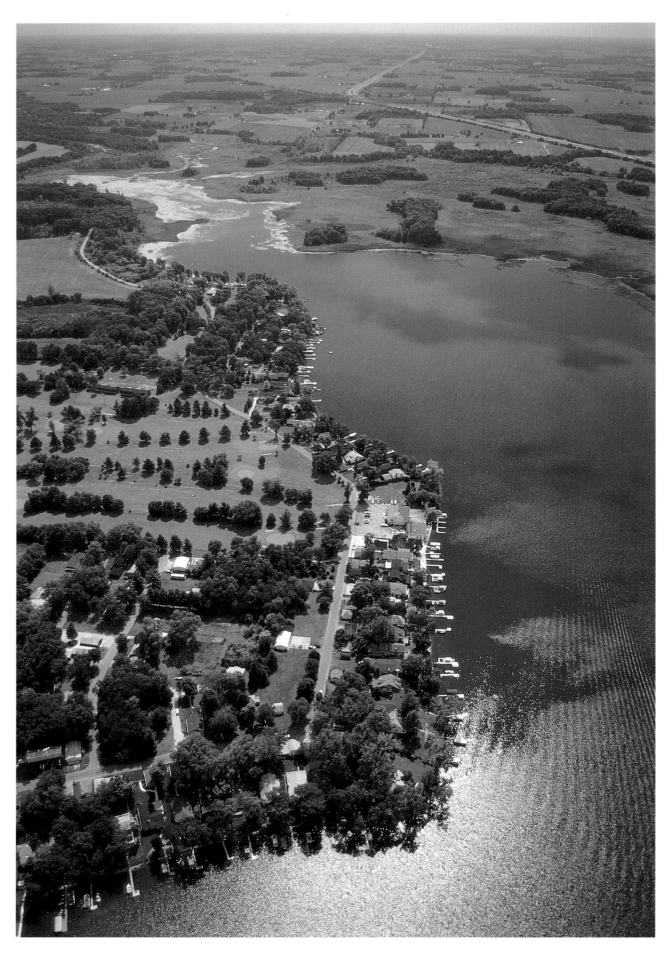

According to legend a serpentlike monster dwells in Lake Manitou in Fulton County. Manitou Island Wetlands (in the distance) protects a sizable portion of Lake Manitou's shoreline in an undeveloped and natural state.

Cooley Lake can't be found on maps these days. Many of Indiana's lakes were previously drained or reduced considerably in size in order to produce additional agricultural land. Here the edge of a marsh marks the former shoreline of a nearly drained lake in northern Elkhart County.

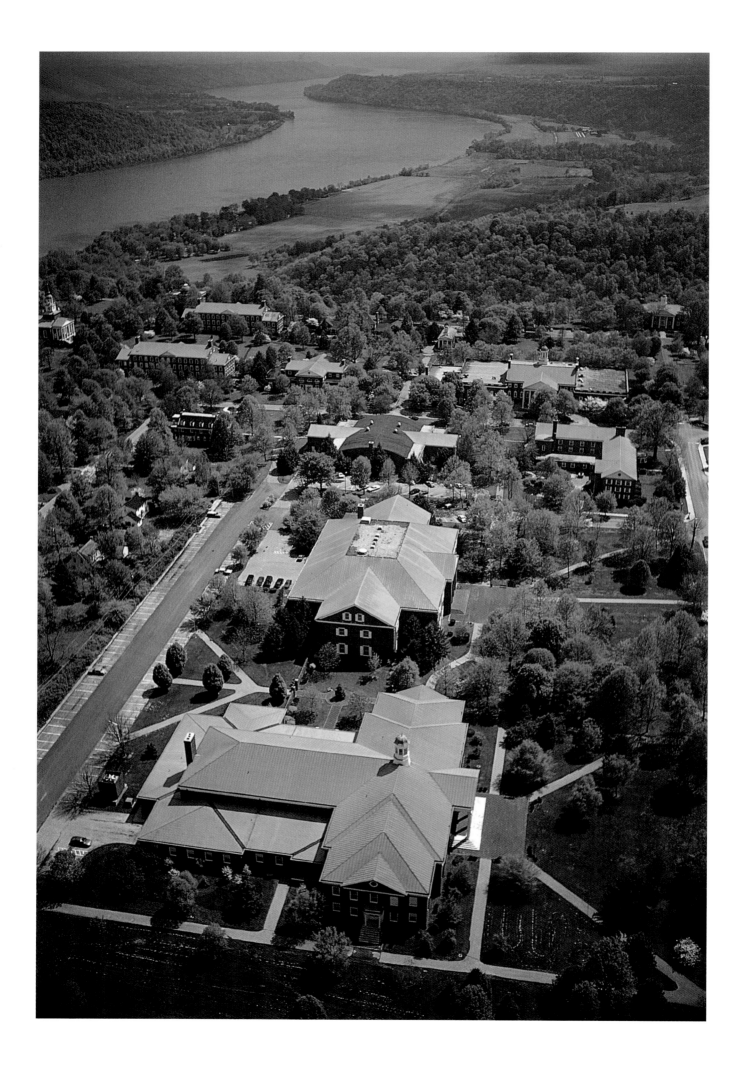

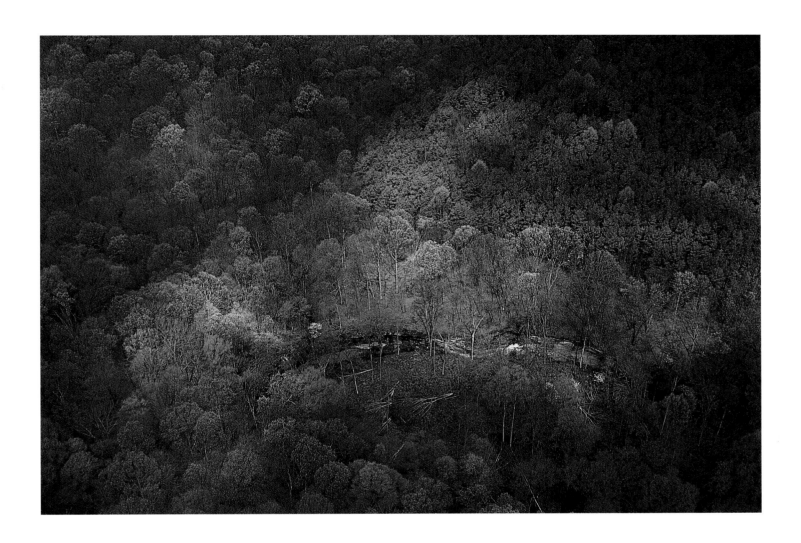

Hanover College in Jefferson County,
founded in 1827, is Indiana's oldest
private liberal arts college.

✳

Rugged sandstone cliffs and rock shelters
line a remote hollow in the Hoosier
National Forest in Perry County.

FOLLOWING SPREAD: *The 2,295-foot-long
Illinois Central Railroad trestle, built in
1906, rises 157 feet above the valley of
Richland Creek, between Solsberry and
Tulip, Greene County.*

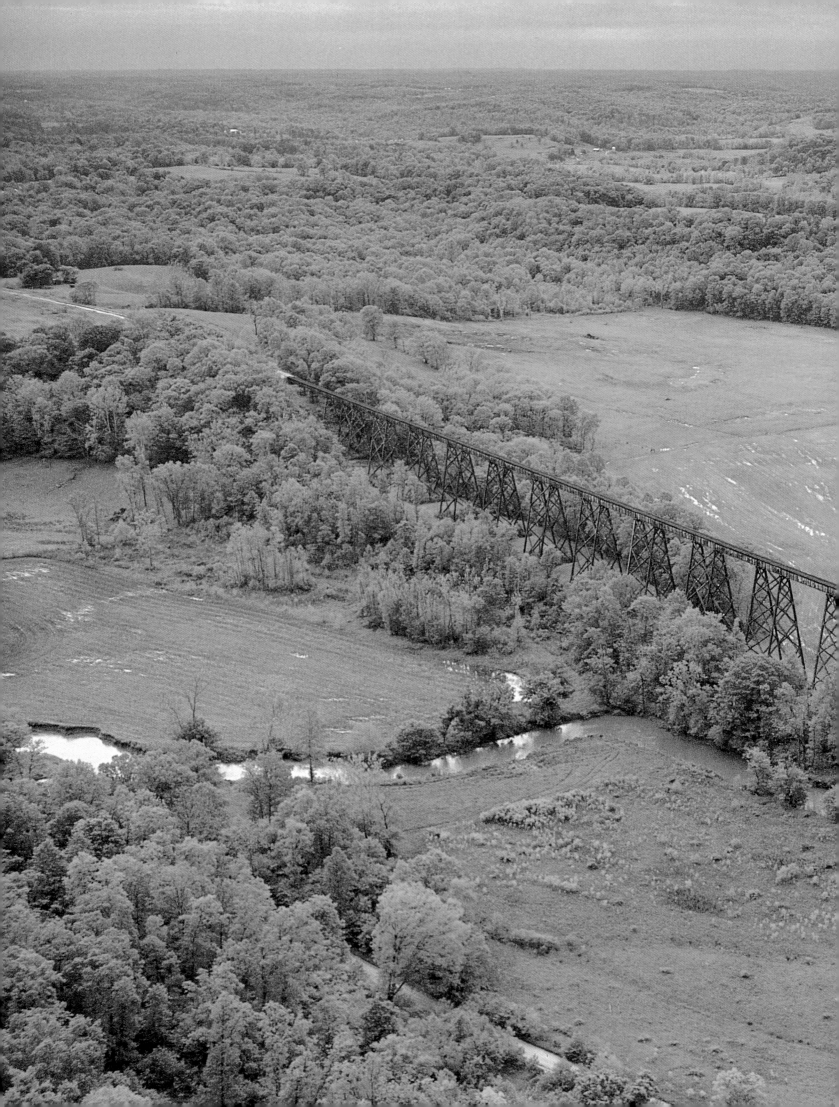

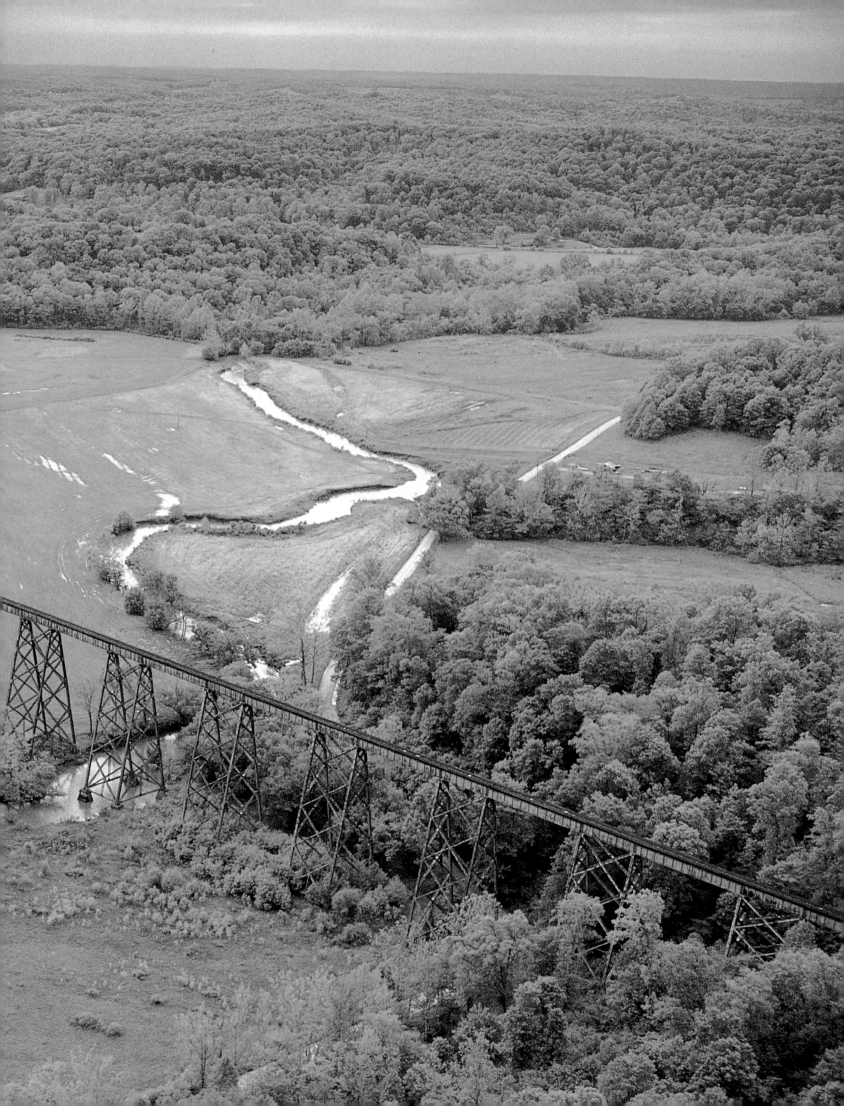

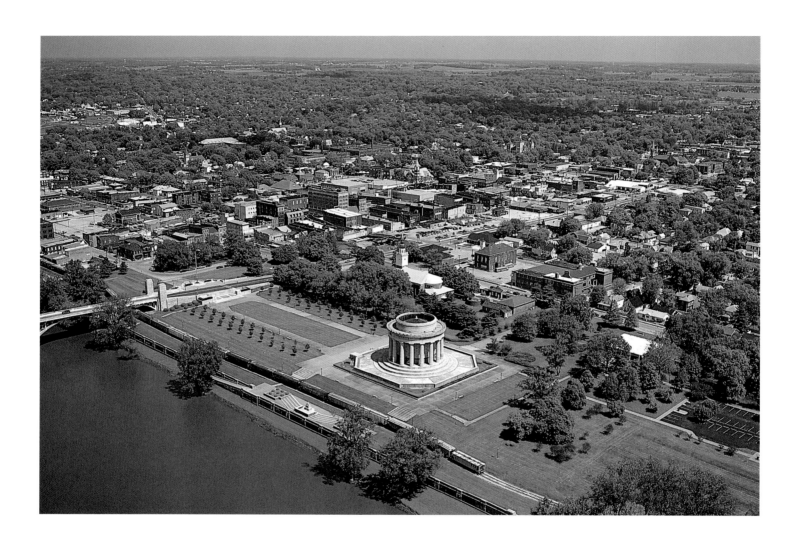

*George Rogers Clark Memorial and
National Historic Park occupy the original
site of Fort Sackville alongside the Wabash
River in downtown Vincennes,
Knox County.*

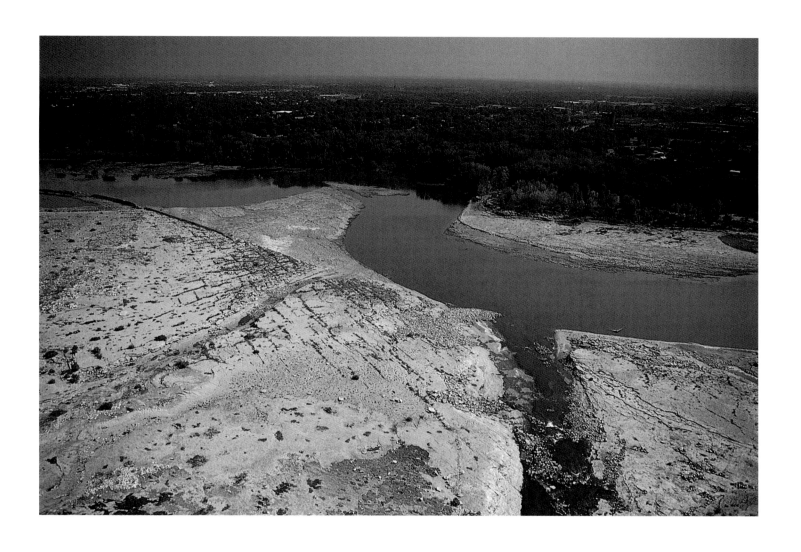

Low water exposes the Falls of the Ohio River. This world-famous Devonian age fossil coral bed is the focus of a new Indiana State Park at Clarksville in Clark County.

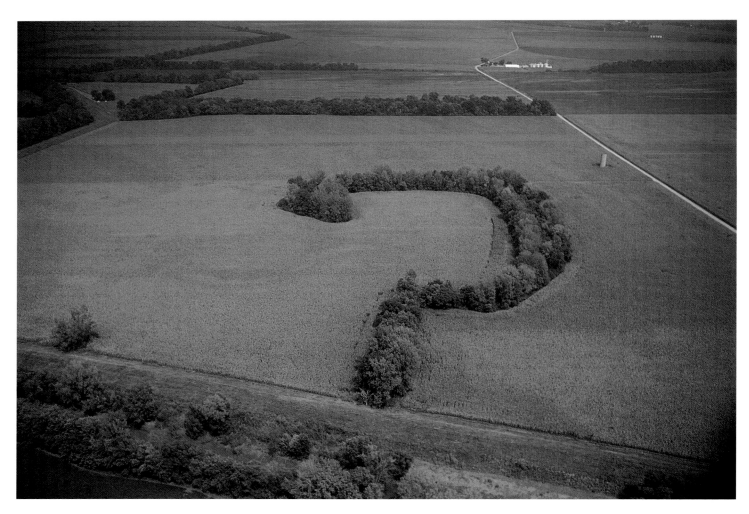

Location uncertain.

Richard Fields *is Chief Photographer, Division of Public Information and Education,
Indiana Department of Natural Resources.*

Hank Huffman *is a biologist with the Indiana Department of Natural Resources.*

BOOK AND JACKET DESIGNER: SHARON L. SKLAR

EDITOR: MELANIE RICHTER-BERNBURG

PRODUCTION COORDINATOR: ZIG ZEIGLER

TYPEFACES: GARAMOND AND ADOBE CASLON

COMPOSITOR: SHARON L. SKLAR

PRINTER: TIEN WAH PRESS (PTE) LIMITED